IMAGES
of America

COLUMBUS
THE MUSICAL CROSSROADS

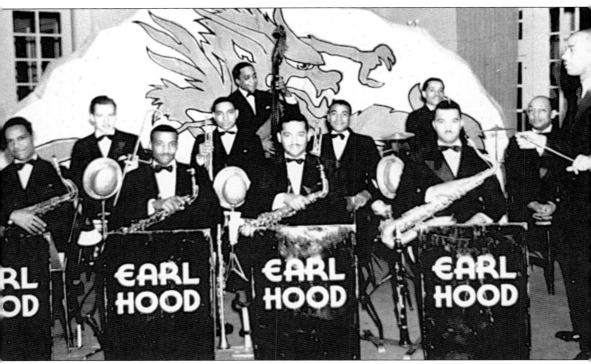

A veteran of the Sammy Stewart Orchestra, Earl Hood went on his own in the early 1920s. He was especially known for his ability to spot raw talent and gave a start to such future stars as Eli Robinson, Joe Thomas, Paul Tyler, and Harry "Sweets" Edison. Because he had a good day job with the auditor's office, Hood was never tempted to leave Columbus.

On the cover: This is a 1955 photograph of the Chuz Alfred Quintet at the Oakhurst Tea Room in Somerset, Pennsylvania. From left to right are Paul Holt, Ola Hanson, Chuck Lee, and Alfred. John Jay is not pictured. (Chuz Alfred.)

IMAGES
of America

COLUMBUS
THE MUSICAL CROSSROADS

10/8/08 Bright moments! Att Howl

David Meyers, Arnett Howard,
James Loeffler, and Candice Watkins

ARCADIA
PUBLISHING

Published by Arcadia Publishing
Charleston SC, Chicago IL, Portsmouth NH, San Francisco CA

Printed in the United States of America

Library of Congress Catalog Card Number: 2008923914

For all general information contact Arcadia Publishing at:
Telephone 843-853-2070
Fax 843-853-0044
E-mail sales@arcadiapublishing.com
For customer service and orders:
Toll-Free 1-888-313-2665

Visit us on the Internet at www.arcadiapublishing.com

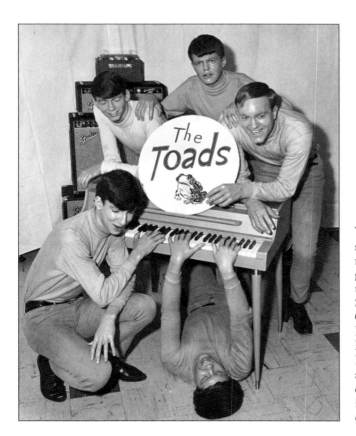

The Toads, who sometimes substituted rubber monster masks for their customary green paint, included (over time) Joel Brown, Rick Stewart, Frank Pierce, Bruce Curtis, Andy Smith, Andy Brewster, Jim Cushman, Mike Howard, Chuck Wilson, and Bill McCanlin. They released a four-song EP that is quite collectable, especially when it is accompanied by the original color postcard. (Chuck Wilson.)

CONTENTS

ACKNOWLEDGMENTS

This book was made possible by all the musicians who generously agreed to share their memories and photographs with us just as they did their music. They knew that all such undertakings are speculative and the chances of anything tangible resulting from them were slim. Nevertheless, they freely gave of their time. We regret that some did not live to see the result of our efforts, but believe they would have been pleased to know that they have been remembered in these pages.

All otherwise unattributed photographs came from the personal collections of the authors or the Listen for the Jazz Archives. We also drew heavily from the collections of Donna Newman (DN) and Local 103 of the American Federation of Musicians (AFM). Individual contributions by musicians or their families are acknowledged in the caption accompanying each photograph. Without the support of them all, there would no book.

Thanks are also due to Elise Meyers for the copy stand work as well as some "digital" darkroom assistance. Finally, we would like to express our gratitude to Melissa Basilone, senior acquisitions editor for Arcadia Publishing, who was a cheerleader and sounding board throughout the process.

The authors share a dedication to rescuing the history of music in Columbus from the dustbins of oblivion. We would like to hear from anyone who is interested in contributing artifacts (photographs, recordings, newspaper articles, programs, posters, personal reminiscences, and so on) to this on-going effort to document Columbus music history. Feel free to contact us at Columbus Senior Musicians Hall of Fame, 54 Glencoe Road, Columbus, Ohio, 43214.

INTRODUCTION

The history of music in Columbus remains largely unwritten. Unlike New York, San Francisco, Kansas City, Nashville, or even Cincinnati, Columbus has never been viewed as having a music "scene." The closest it came was the early 1990s, when *Entertainment Weekly* suggested it might be "the next Seattle." It was not. But then, it is hard to market the "Columbus sound" because it does not really have one.

While people have been making music here for more than 200 years (at least as far back as the death song of Sha-Te-Yah-Ron-Ya, or Chief Leatherlips, in 1810), little recognition has been given to that fact. Even when a Columbus musician attains national prominence, his or her roots are often overlooked. That is because they invariably have to go somewhere else to "make it big."

Ragtime pianist Terry Waldo once said that New Yorkers think they "discovered" him, when, in fact, Columbus already had years before he moved to the Big Apple. He also observed that there was no one in New York who could play the piano any better than his former teacher, Johnny Ulrich. Of course, Ulrich's many hometown fans suspected that too.

What sets Columbus apart from traditional music scenes is its location. Originally platted in a densely wooded area traversed by barely perceptible hunting trails, it had little to recommend it save that it was in the middle of the state. Nevertheless, Ohio's capital city eventually came to be located at the intersection of two great and storied highways, Route 40 and Route 23 (and later, Interstate 70 and Interstate 71).

Established in 1925, Route 40 extends from Atlantic City to San Francisco and incorporates the earlier National Road, the first federal highway project. A year later, Route 23 was mapped out from Mackinaw City, Michigan, to Portsmouth, Ohio (and by 1951 reached down to Florida). Then in 1928, famed aviator Charles Lindbergh chose Columbus as the eastern transfer point for Transcontinental Air Transport, enabling passengers to travel from coast to coast by rail and air in as little as 48 hours.

Today more than half the population of the United States lives within 550 miles of Columbus, and historically this proportion was even higher. Before commercial air travel was in wide use, anyone crossing the country from east to west was apt to drive along Route 40, while Route 23 was a major conduit for snowbirds going south and Appalachian job seekers (who had been taught, "Readin', Rightin', and Rt. 23," in the words of Dwight Yoakam) heading north.

The city's claim on the title "Crossroads of America" was certainly as good as many and better than most. Even today, Columbus is a major logistical hub because of its strategic location. However, its credentials as a musical crossroads are just as indisputable although less heralded.

During the big band era, nearly every major white group stopped off at the venerable Valley Dale ballroom in Columbus on their way to somewhere else, while popular black acts performed regularly at such venues as the Lincoln, Lane-Askins, and Greystone Ballrooms. Because of its location, Columbus was also the home base for many touring groups. For example, Grover Washington Jr. started here with the Four Clefs.

As home to Ohio State and Capital Universities (as well as several others), Columbus has benefited from the yearly influx of new music students into the area. Following World War II, Lockbourne Air Force Base became a magnet for young African American musicians owing to its acclaimed music program, which produced such well-known jazz figures as Dwike Mitchell, Willie Ruff, and Elvin Jones. Even though Columbus was never a major factory town, its low unemployment rate has drawn many migrants from Kentucky and West Virginia and, with them, their music.

Looking at the history of music in Columbus, its most striking feature is the diversity of influences. There never has been a distinctive sound because Columbus musicians are not a particularly homogeneous group. Instead, there are many sounds, each reflecting the cultural makeup of a neighborhood—jazz and rhythm and blues predominated on Mount Vernon Avenue, country and rockabilly held sway on Parsons Avenue, and practically anything could be heard at one time or another on High Street near the Ohio State University campus.

There is no question that Columbus musicians can compete with musicians anywhere, and they do. While only a handful have become household names, many others have worked quietly behind the scenes, helping to shape the development of popular music in America. No one understood that better than the late Robert D. Thomas. In 1994, Thomas and I founded the Columbus Senior Musicians Hall of Fame as a vehicle for publicizing the area's rich musical heritage through recognizing some of the musicians and groups that have made significant contributions to it.

What follows is an attempt to shoehorn 70 years (1900–1970) of Columbus music history into 200 or so selected images. It should in no way be considered a comprehensive account, although I have endeavored to make it as balanced as possible, given the limitations of the source materials.

—David Meyers

One

THE GREAT BAND BUILDERS

In 1900, the population of Columbus was 125,560, making it the 28th largest city in the United States. It lagged far behind Cleveland (seventh), Cincinnati (10th), and even Toledo (26th). Despite being the state capital, Columbus was regarded as a big town and not a proper city at all. One could look in vain for it on most national maps. However, by 2000, Columbus had jumped to 15th (with a population of 711,470), while Cleveland fell to 33rd, Cincinnati 54th, and Toledo 56th. It was the tortoise and the hare all over again.

These other cities had initially benefited from their locations on major waterways, which facilitated early immigration and spurred economic development. Columbus, on the other hand, had been staked out near the center of the state at a spot known as Wolf's Ridge. Except for some heavy politicking by local property owners, there was little reason to locate the future state capital here. But that soon changed.

Roads were built, canals were dug, tracks were laid, and the first transcontinental airlines established, truly making Columbus a crossroads for travelers passing from east to west and north to south. What was once a fairly isolated village began to grow and prosper.

At the dawn of the 20th century, live music was the primary form of entertainment. Even the most meagerly furnished homes often had a piano. Brass bands were popularized by John Phillip Sousa, and it was a poor community indeed that had only one brass band.

Musical aggregations of the time were white, black, or whites "corking up" to masquerade as blacks (and, occasionally, blacks corking up, as well). In Columbus, the great white band builders included Frederick Neddermeyer, Charles T. Howe, and Gustav Bruder, while their African American counterparts were Charles Parker and Thomas Howard. Occupying the middle ground was Al G. Field, proprietor of the largest and arguably most successful minstrel show of all times.

Polk's City Directory for 1900 advertised eight musical organizations: Columbus National Band, Fourth Regiment Band, Grand Opera House Orchestra, High Street Theatre Orchestra, Italian Orchestra, Knights of Pythias Band, Neddermeyer's Band, and the Columbus Battalion Band. While this list should not be considered comprehensive, it does provide an interesting benchmark because all of these groups were composed of white musicians. Within four years, however, they were joined by Howard's People's Orchestra and Parker's Columbus Orchestra.

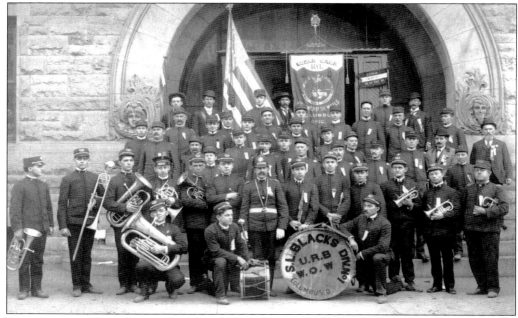

The director of S. L. Black's Woodmen of the World Band no doubt benefited from the fact that Columbus had some 72 music teachers in 1900. Of course, many musicians were self-taught or, more likely, learned to play an instrument from a parent or other family member. In those pre-radio days, people were more accustomed to providing their own entertainment.

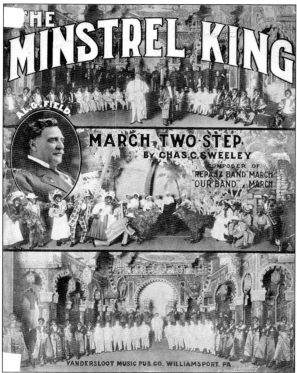

Born in Pennsylvania and reared in Chillicothe, Al G. Field made Columbus his adopted hometown and the staging area for his famous minstrel shows. He founded Al G. Field's Greater Minstrels in 1886, embarking on annual tours that began in Columbus during Ohio State Fair week then headed out across the country. Although Field died in 1921, his show went on until 1927.

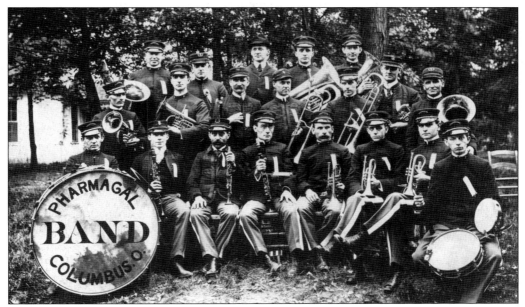

Pharmagal (seen in their winter uniforms) was an example of a company band. It was sponsored by the Columbus Pharmacal Company (originally Cornell-Pheneger Brothers), a manufacturer and wholesaler of drugs, surgical instruments, and artificial limbs. Other company-sponsored ensembles included the Hallwood Cash Register, Ohio Malleable, and Dispatch Newsboys Bands.

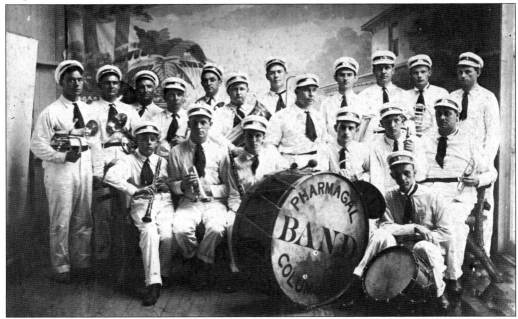

Founded in 1885, the Columbus Pharmacal Company continues to this day as Roxane Labs, a subsidiary of Boehringer Ingelheim. Among the members of the Pharmagal Band (seen in their summer uniforms) was employee Fred Loeffler, an instrument maker and grandfather of James Loeffler, one of the authors of this book.

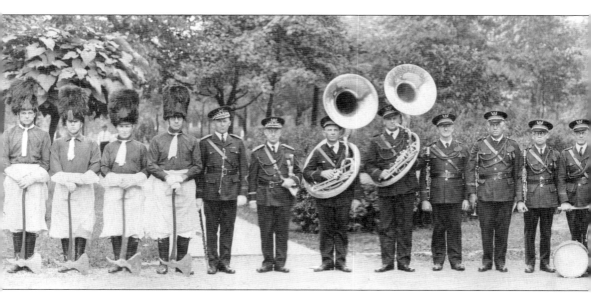

During World War I, photographers took many panoramic shots of military units, including military bands. The Ohio Brigade Band was part of the Fourth Infantry Regiment Ohio National Guard, which was renamed the 166th Infantry Regiment when it was made part of the 42nd

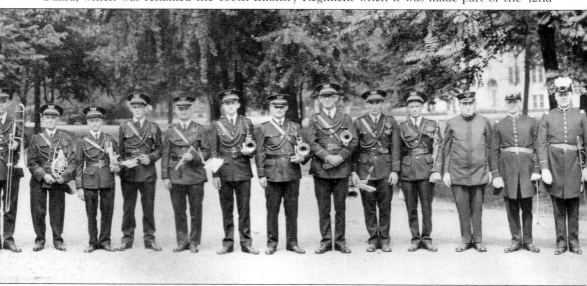

Infantry "Rainbow" Division. However, almost to a man it doubled as the Eastwood Company No. 101 of the Uniformed Rank Knights of Pythias Band, a fraternal order. The band was directed by Dean Sisson and the drum major was Police Chief Fred Koontz. (AFM.)

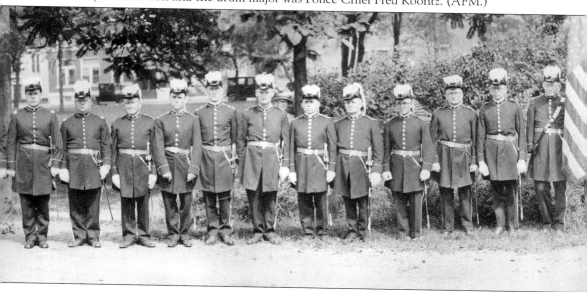

In addition to playing in the Pharmagal Band, Fred Loeffler was a Mason and a member of the Aladdin Temple Shrine Band. He was also a professional photograph finisher, photographer, and stage actor, which may explain why his descendants have so many great vintage photographs depicting life in Columbus from about 1900.

Frederick Neddermeyer (on left) rose through the ranks from being a music holder at the Comstock Opera House to studying at the Royal Conservatory in Leipzig before returning home to lead the Metropolitan Opera House orchestra. Soon he was the most prominent bandleader in Columbus, organizing a number of local bands under his own name and others. (AFM.)

The enterprising Neddermeyer formed bands, orchestras, and symphonies—whatever was required for the occasion. Although he also worked in Detroit for a number of years, Columbus was his home, and he returned here to conclude his career. Neddermeyer also was an occasional composer of marches and two-steps, often to commemorate special events. (AFM.)

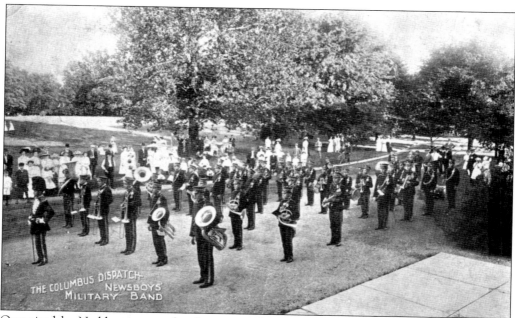

Organized by Neddermeyer under the sponsorship of the *Columbus Dispatch* newspaper, the Columbus Dispatch Newsboys Band provided free civic concerts, such as in 1910 when they performed on Watkins Island at Buckeye Lake. It was about this time that Neddermeyer left for Detroit where he remained for 11 years.

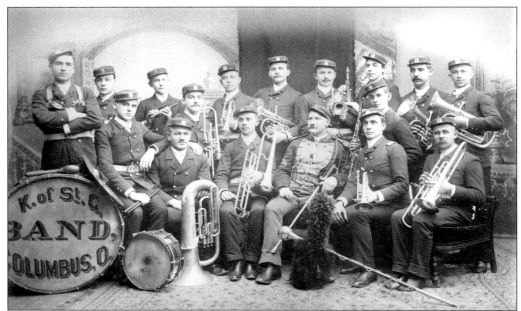

A. J. Gassman had formerly been the conductor of St. Cecilia's Band. He then moved to the Knights of St. George Band, which was in existence from 1886 to 1897. Gassman remained with the group until it was reorganized into the Columbus Battalion Band. They were named for St. George of Lydda, who was martyred by the Roman Emperor in the fourth century. (AFM.)

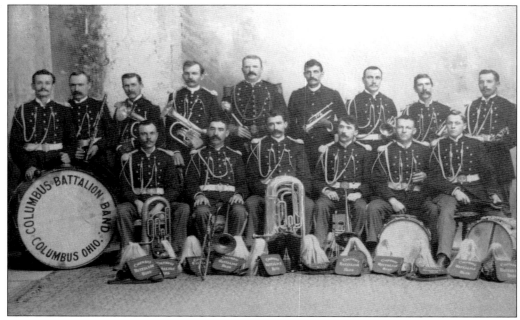

When the Knights of St. George Band folded, the entire membership was retained as the Columbus Battalion Band with the exception of A. J. Gassman, who was replaced as director by Jacob Rechenwald. Rechenwald was succeeded by the highly respected Max Neugebauer of the Fourth Battalion and Columbus National Bands. (AFM.)

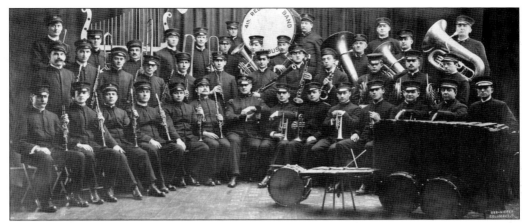

The Fourth Regiment Band, led by Jesse Worthington, grew out of the 4th Ohio Volunteer Infantry, which was formed in Columbus on April 25, 1898. Upon the unit's return home from the Spanish-American War, it was absorbed into the Ohio National Guard. The band continued to perform for many years. (AFM.)

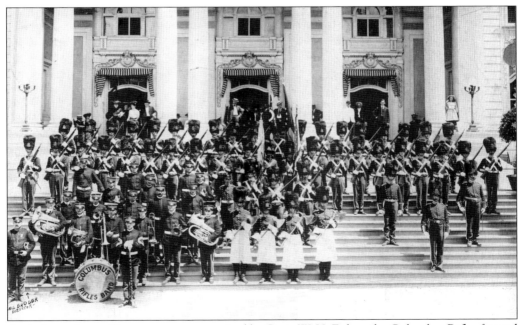

An independent military company organized by Capt. W. H. Fisher, the Columbus Rifles formed their own band conducted by Gustav Bruder. Bruder had been accepted into the U.S. Army at the age of 12, and was offered a position playing cornet in John Philip Sousa's U.S. Marine Band. His military band experience was to serve him well in his future endeavors. (AFM.)

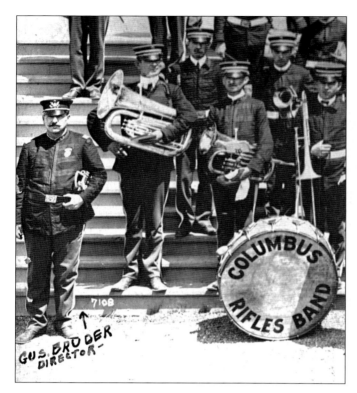

After a stint as leader of a circus band, Gustav Bruder was hired as the first professional director of the Ohio State University band in 1896. At the time, it had only a dozen members. During his tenure, Bruder expanded the band to 100 pieces, introduced choreographed formations, and played at the dedication of Ohio Stadium. (AFM.)

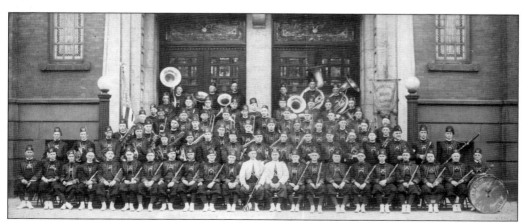

When Raymond Zirkel, a veteran of Al G. Field's minstrels, staged an original musical comedy at a meeting of the Ancient Arabic Nobles of the Mystic Shrine, a small German band was prominently featured. The Shriners quickly decided to form a band of their own, appointing Zirkel as leader and George Moore as conductor.

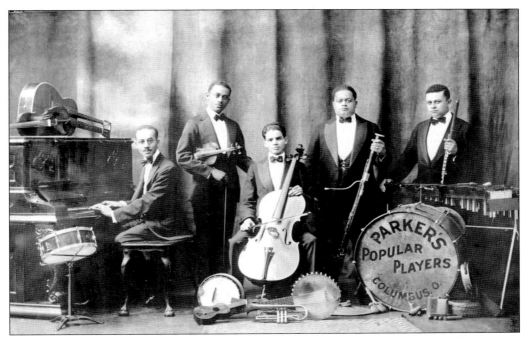

Charles A. Parker, a barber and violinist, managed as many as 38 bands throughout the Midwest, several of which bore the name Parker's Popular Players. As early as 1904, he was also managing something called the Columbus Orchestra.

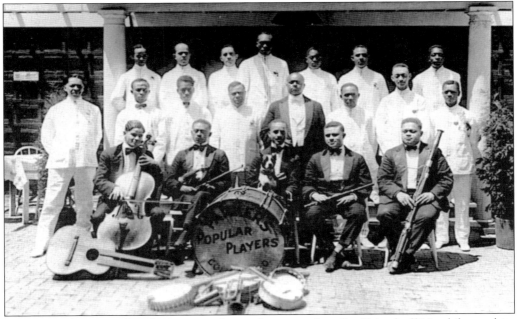

In 1910, Parker's Popular Players were playing "tea music" at the Kaiserhoff Hotel for a white clientele. Parker was able to attract "the cream of the crop," according to bandleader Earl Hood. It is not surprising that the Sammy Stewart Orchestra was formed from many of these same musicians when Stewart left Parker's Popular Players in 1918.

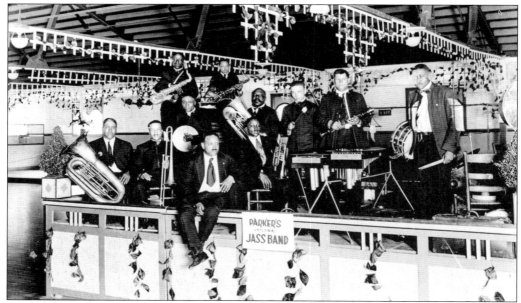

Charles A. Parker tried to be all things to all people, as evidenced by this photograph of Parker's Original Jass Band. The term "jass" evolved into the more familiar "jazz" sometime around 1917, which suggests that Parker was right on top of the latest trends. Only a few years earlier, ragtime had been all the rage.

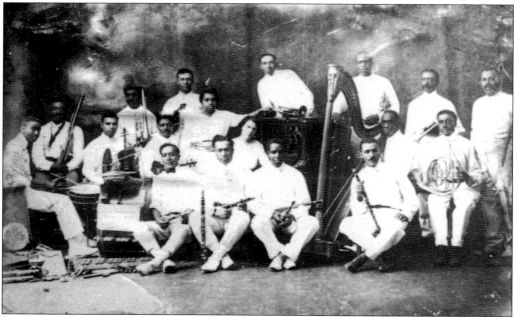

A Long Street restaurant owner, Thomas (Tom) Howard also was a well-known African American booking agent. Although he preferred to remain behind the scenes, he did play the tuba or string bass on occasion. During the 20th century, the proportion of black residents in Columbus increased from seven percent to 24.5 percent (or 9,000 to 174,065).

Howard had organized his 30-piece People's Orchestra sometime in the 1890s, and it was in existence for about eight years. He also managed the Orchestra Deluxe. Howard's bands traveled widely. For example, in 1922 the Orchestra Deluxe was playing at the Dreamland Japanese Garden in Chicago, while the Whispering Orchestra of Gold had made an ill-fated trip to Florida.

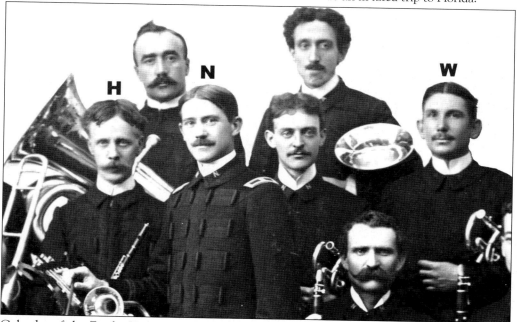

Coleader of the Ziegler-Howe Orchestra with violin virtuoso Franz Ziegler, Charles T. "Teach 'Em" Howe (shown with Fred Neddermeyer and Jess Worthington) is best remembered today for his development of the Howe Model Conn flute with an ebonite head and metal body. He also wrote several books on the "Howe method" of flute, and contributed to Henry Howe's Historical Collections of Ohio. (AFM.)

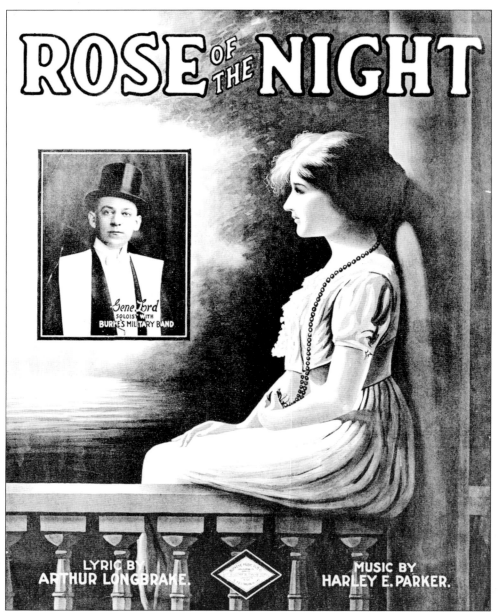

The father of eight sons and four daughters, Charles M. Burke formed Burke's Military Band in 1897 with his seven eldest sons. It remained strictly a family ensemble until 1906, when it expanded to 35 members, with Grover C. Burke conducting. By 1917, dapper Gene Ford (pictured) was a vocalist with the group and introduced the song "Rose of the Night." It was issued by Buckeye Music Publishing, one of a handful of music publishers operating in Columbus during this period. Throughout the summers of 1918 and 1919, Burke's band played Olentangy and Indianola Amusement Parks. It is likely that the band's style evolved to reflect the changes occurring in popular music, from marches to ragtime, two-steps, and foxtrots. However, it probably never moved into jazz, since its final performance (under the baton of Lott B. Burke) was for the inauguration of Gov. Harry Davis in 1921.

Two

GOING ON RECORD

Ohio-born Thomas A. Edison was responsible for the first practical device for recording sound, making the recording industry possible. In typical Edison fashion, he felt his invention was more important than the musicians he recorded, and it was only with great reluctance that he began adding their names to the record labels—next to his own. Consequently, many of the earliest recording artists remained anonymous.

The question of who was the first Columbus musician to make a recording cannot be answered with any degree of certainty. Several members of Al G. Field's minstrels were recording pioneers, most notably William (Billy) Murray, who was regarded as the top-selling recording artist in the country from 1900 to 1920. Starting in 1897, he made 169 solo recordings, 18 of which would have reached the top of the charts had any existed at the time. However, Murray, originally from Philadelphia, stayed with Field only briefly, leaving the show when it reached New York.

One of the earliest recordings by a Columbus musician is also one of the most important "lost" recordings of all time. Pierre de Caillaux (also known as Lionel Jones) had gone to England as a piano player in Will Marion Cook's Southern Syncopated Orchestra, which included young clarinetist Sidney Bechet, considered by many historians to be the most important jazz soloist before Louis Armstrong. While in London, the two of them jumped to another band, Benny Payton's Jazz Kings, and made a half-dozen or so recordings for English Columbia. However, none of them was ever released, possibly due to technical flaws.

In the early 1920s, independent record labels, such as Okeh, Paramount, and Gennett began to proliferate. As a result, even a small town such as Richmond, Indiana, home of Gennett, might become a recording center. However, because there were no such facilities in Columbus, all early recordings by Columbus musicians were made elsewhere until the introduction of home recording equipment around 1930.

As early as 1931, someone in Bexley recorded local musical acts off the radio on a Victor home recording machine. A decade later, William Loeffler (the father of one of the authors) began dragging a portable record-cutting machine around to local clubs and captured the sound of many Columbus artists who otherwise would not have been recorded. It was not until 1943 that Columbus acquired a true recording studio, Coronet, founded by oboe player Robert E. Buchsbaum.

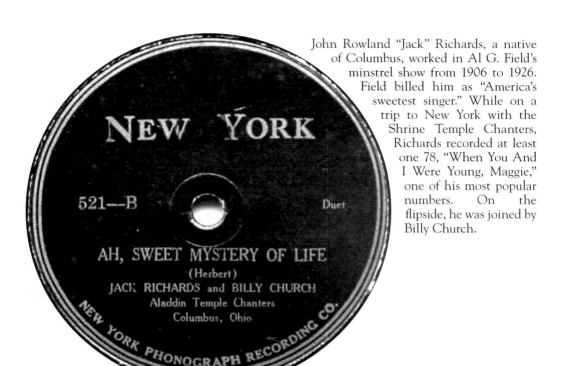

John Rowland "Jack" Richards, a native of Columbus, worked in Al G. Field's minstrel show from 1906 to 1926. Field billed him as "America's sweetest singer." While on a trip to New York with the Shrine Temple Chanters, Richards recorded at least one 78, "When You And I Were Young, Maggie," one of his most popular numbers. On the flipside, he was joined by Billy Church.

Many of the songs published in Columbus were written by members of Field's minstrel show. This one includes not only a likeness of minstrel Richards but also of Al and Don Palmer, after whom the famous deejay Aldon "Alan" Freed was named. One of the most enduring contributions made by Field's minstrels was the founding of the Charity Newsies.

Elsie Janis, born Elsie Janis Bierbower, was the Shirley Temple of her day and the first Columbus native to become a major star, appearing on the stage in New York and London. Janis recorded a few dozen songs, beginning in 1912 with "That Fascinating Baseball Slide," followed by, "When Antello Plays The 'Cello," and "Fo' De Lawd's Sake, Play A Waltz." She was also a songwriter of some note.

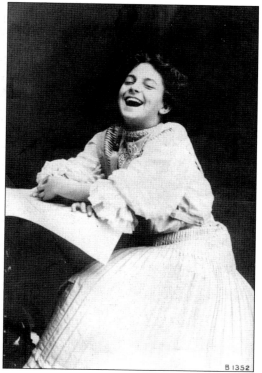

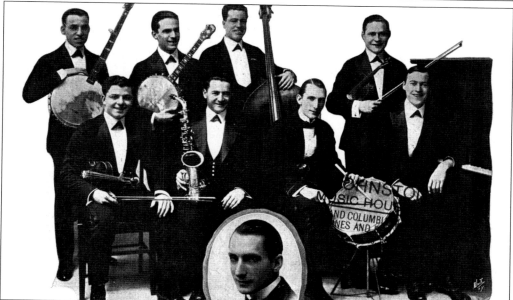

After running away from his music store job in Columbus, Theodore Friedman joined up with Earl Fuller's Famous Jazz Band in 1917, recording six tunes the first year followed by "Jazzbo Jazz One-Step," a song that was described in the August issue of the *Edison Amberola Monthly* as "a real, red-hot jazz dance of the most ultra modern variety." Friedman's hokey clarinet playing was cutting edge.

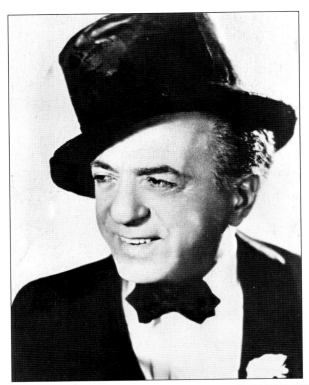

Friedman, who took the stage name Ted Lewis, was the highest-paid man in show business by 1925 and was highly respected for his ability to discover talented musicians, including Benny Goodman, Jack Teagarden, and the Dorsey Brothers. Over a career that spanned half a century, he recorded hundreds of songs and made a number of movies. There is a small museum devoted to him in his hometown of Circleville.

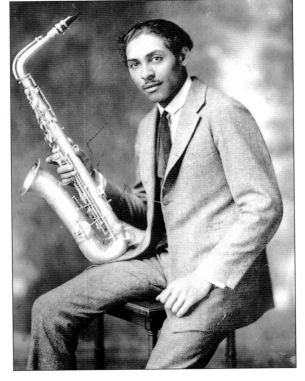

Singer and sax player Lois Deppe was operating out of Pittsburgh when Deppe's Serenaders cut six sides for Gennett Records in 1923, featuring his discovery, teenage pianist Earl Hines. Within two years, Deppe claimed Columbus as his home and kept it as his base until 1937, including the period in which he was a member of the original cast of the landmark Broadway musical *Showboat* and several other shows.

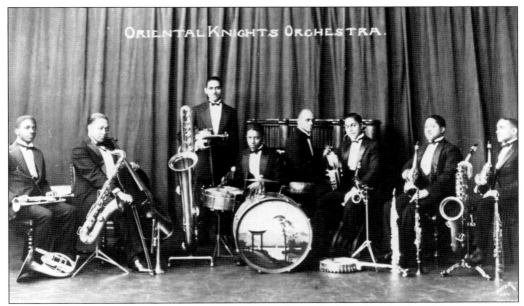

Sammy Stewart, a proponent of symphonic jazz, took his band of mostly Columbus musicians to Chicago in 1921 and quickly established it as one of the top five musical aggregations in the city. Between 1924 and 1928, Stewart and his orchestra recorded seven tunes that were subsequently released under his own name as well as several others. He later moved to New York City but could not repeat his success.

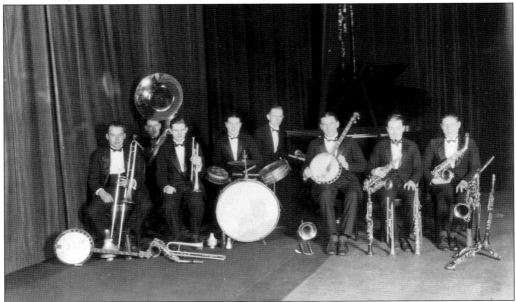

Stewart's recording of "My Man Rocks Me" was one of the earliest mentions of the term "rock" in music. In 1925, Harold Ortli and His Ohio State Collegians, a band composed of Ohio State University students, recorded "My Daddy Rocks Me (With One Steady Roll)," while Ortli was home on vacation in Cleveland. For a time, some collectors believed the cornet player, Frank Zeeck, was actually Bix Biederbecke. (Jack Smith.)

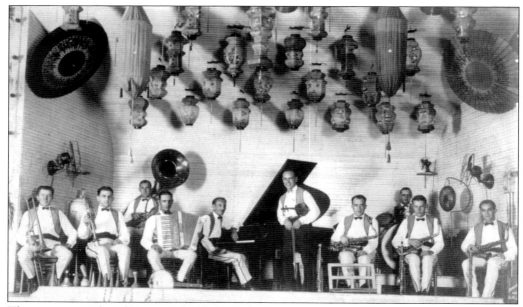

The same year, Edward Harrison (Eddie) Mitchell, an automobile salesman by day and bandleader by night, took his orchestra to Richmond, Indiana, and recorded "Pleasure Mad," backed with "Pickin' Em Up And Layin' Em Down," in the primitive recording studio known as "the shack by the track," operated by the Gennett Piano Company. The recording was a hit in Columbus, especially at Olentangy Park. (AFM.)

Lawrence "Beau" and Vance Dixon joined with Kline Tyndall, a fellow member of Sammy Stewart's Ten Knights of Syncopation, to record four tunes as Dixon's Jazz Maniacs: "DAD Blues," "Tiger Rag," "Crazy Quilt," and "My Man Just Won't Don't," in 1926. Beau, from Chillicothe, went on to have a lengthy career as a jazz guitarist, but Vance burned out early. They were not related.

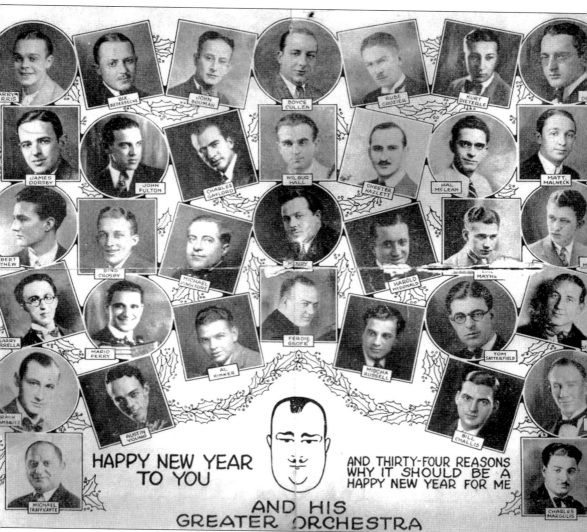

HAPPY NEW YEAR TO YOU AND THIRTY-FOUR REASONS WHY IT SHOULD BE A HAPPY NEW YEAR FOR ME

AND HIS GREATER ORCHESTRA

Bing Crosby idolized Austin "Skin" Young, a Columbus singer who joined Paul Whiteman after leaving home. Crosby wrote that, "Skin had a tremendous range. He could go very high and very low . . . he could sing blues songs and fast rhythm songs and he could make songs as uninhibited as a pre-Cab Calloway." Young can be heard on such classic Whiteman recordings as "Chloe" and "Felix the Cat" in 1928, although he was usually in a vocal trio. In this advertisement for Whiteman's band, Young is directly above the word "happy," while Crosby is two pictures above him. Also pictured are the Dorsey Brothers (first row, right, and second row, left) and Bix Beiderbecke (first row, second from left). Surviving payroll records show that Young was one of the higher-paid members of the Whiteman organization. (Duncan Scheidt.)

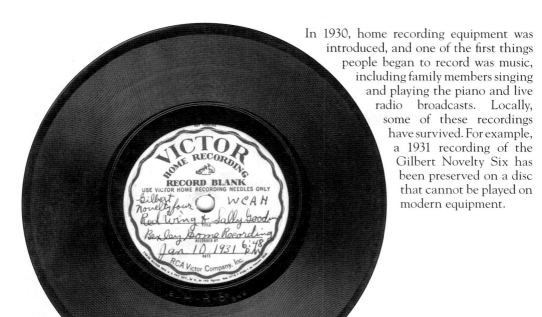

In 1930, home recording equipment was introduced, and one of the first things people began to record was music, including family members singing and playing the piano and live radio broadcasts. Locally, some of these recordings have survived. For example, a 1931 recording of the Gilbert Novelty Six has been preserved on a disc that cannot be played on modern equipment.

In 1939, William Loeffler started Allied Record Service and began recording local musicians with an over-head lathe disc-cutting machine of his own design. The following year, he hauled his machine to a jam session at the Variety Club where famed trumpeter Bobby Hackett was accompanied by a pick-up band of Columbus musicians.

30

A second session took place at the Loeffler home in Clintonville a day later with copies issued to the participants. Listening to the playback are Steve Bernard (violin), Hank Harding (guitar), and Jimmy Metz (drums). Among the other recordings Loeffler made were of pianist Bill Tye, singer Madame Rose Brown, and jam sessions at the Colored American Legion hall and the Colored Musicians Union hall.

Originally from Savannah, Georgia, Madame Rose Brown came to Columbus to visit relatives and stayed to sing in the clubs. In 1939, she costarred with Bill "Bojangles" Robinson in the Broadway show *The Hot Mikado*. She was seldom recorded, and no one recorded her better than William Loeffler at the Canteena Club.

In 1941, the Lane Askins Ballroom booked many traveling acts (such as the one pictured) and had an outstanding house band that included Al Freeman, Sammy Hopkins, Bus Brown, and Howard "Fats" Smith. William Loeffler recorded the group playing three songs. This photograph was the only one salvaged when the ballroom was demolished.

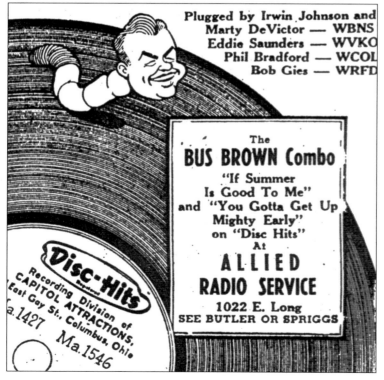

Plugged by Irwin Johnson and
Marty DeVictor — WBNS
Eddie Saunders — WVKO
Phil Bradford — WCOL
Bob Gies — WRFD

The
BUS BROWN Combo
"If Summer
Is Good To Me"
and "You Gotta Get Up
Mighty Early"
on "Disc Hits"
At
**ALLIED
RADIO SERVICE**
1022 E. Long
SEE BUTLER OR SPRIGGS

Disc-Hits
Recording Division of
CAPITOL ATTRACTIONS,
East Gay St., Columbus, Ohio
a. 1427
Ma. 1546

The Bus Brown Combo recorded a couple of tunes by Bill Copeland of Byer-Bowman Advertising and Geer Parkinson of WBNS radio for release in 1949 on the Disc-Hits label started by Copeland and agent Howdy Gorman. Brown had been a featured vocalist with the Lucky Millinder Orchestra before returning to Columbus. Disc-Hits must have been one of, if not the earliest, Columbus labels.

Also in 1949, Three B's and a Honey, a group that formed in Baltimore three years earlier before moving to Columbus, went into the studio at WCOL radio and recorded a single that was released on the Savoy label out of New Jersey called "Buzzin' Around" backed with "Grieving for You." They remained in Columbus while their leader, Bobby Smith, attended Ohio State University.

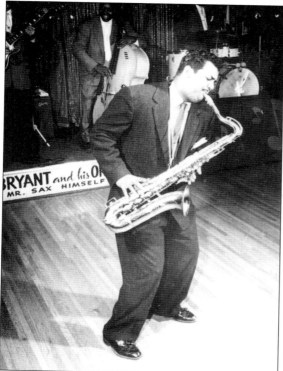

The first important record to come out of Columbus was "All Nite Long" in 1954, a double-time version of "Night Train" recorded live at the Carolyn Club by tenor man Royal G. "Rusty" Bryant and his band, which included Hank Marr, Fred Smith, and Jimmy "Stix" Rogers. The excitement was captured by recording engineer Robert Buchsbaum using one Telefunken microphone hanging from the ceiling.

At age 13, Art Ryerson started taking banjo lessons from a door-to-door music teacher. After working for a time as a staff guitarist on WLW radio, Ryerson played with such well-known bandleaders as Paul Whiteman and Raymond Scott before settling into a lengthy career as one of the most sought-after session men in New York.

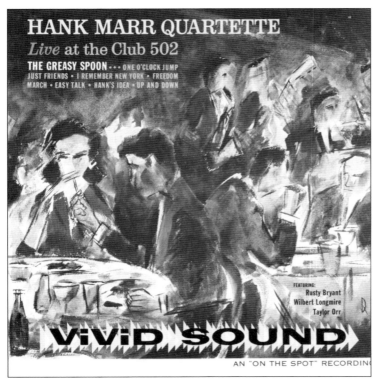

Live At the Club 502 reunited Hank Marr with Royal G. "Rusty" Bryant for what many believe is the greatest live album ever recorded in Columbus. With Taylor Orr on drums and Wilbert Longmire on guitar, the duo showed they had not been standing still since their Carolyn Club days a decade earlier. However, at least a few of the tracks were recorded in the studio with crowd noises added later.

34

Three

DANCE HALL DAYS

The dance craze was ushered in by Vernon and Irene Castle, the swanky Brit and the sexy American, who made the fox-trot an acceptable form of self-expression for the middle and upper classes. It is not that people were not already dancing to the syncopated rhythms of the day, but those who did, especially in public, were often looked down upon as crude and vulgar. The Castles, however, were promoted as the very embodiment of culture and refinement.

Not surprisingly, there were some who resisted society's mad dance into the jazz age. A gulf existed between "hot music" and "sweet music" that tended to parallel the racial divide. In January 1925, when 16-year-old Dorothy Ellingson of San Francisco killed her mother, put on her party dress, and went dancing, her attorney blamed her behavior on "jazzmentia" or "jazzmania." Many a mother's (and father's) worst fears were confirmed. Nevertheless, across the country, ballrooms began sponsoring dance contests or providing fox-trot, waltz, tango, Charleston, and black bottom lessons.

Over the years, Columbus has been home to a number of dance halls and ballrooms, the most famous of which is Valley Dale. Originally built as a stagecoach stop in the 19th century, it was converted to a roadside inn and dancing pavilion in 1918. After it burned down five years later, it was rebuilt to include an indoor and an outdoor dance garden so patrons could dance beneath the stars. Valley Dale continues to be used as a music venue. Other Columbus dance halls included Olentangy Park, Minerva Park, Smith's Dance Hall, Graystone Ballroom, Lane-Askins Ballroom, and Lincoln Ballroom.

In 1919, the Texas Tommies played Indianola Park's Danceland. They were named after a dance that had originated a decade earlier in San Francisco, the Texas Tommie Swing. Billy Murray, formerly of Al G. Field's minstrels, had a hit song with it in 1912. It was the first use of the term "swing" in dancing. Interestingly, the Castles did not approve of the dance, helping to ensure it quickly fell out of favor.

During the 1920s, phonograph records eclipsed the sales of sheet music and piano rolls. Annual record sales peaked in 1927 at 140 million then rapidly dropped to six million in 1932 as the Great Depression settled in. Still, the dancing did not stop, and many Columbus bands were ready to supply the music.

Columbus was once known as "the Arch City," owing to the numerous illuminated arches spanning its downtown streets. The arches were apparently the inspiration for the dance that Prof. W. J. Rader taught in his three dancing academies on High Street, Oak Street, and Neil Avenue, as well as this composition by Samuel E. Morris.

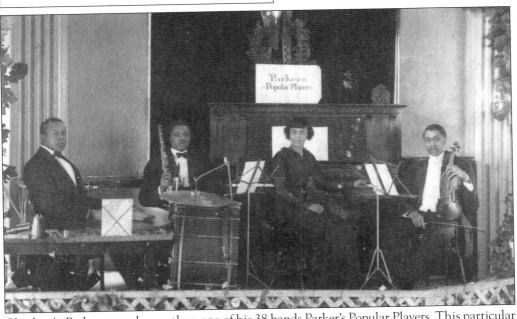

Charles A. Parker named more than one of his 38 bands Parker's Popular Players. This particular group featured pianist Mamie Artis, one of the few female musicians from this period who are known by name (although there were others). The drummer is Carl "Battle-Axe" Kenny, who played with James Reese Europe's 369th Infantry Hellfighters Band. Bandleader Paul Whiteman chose Kenny to play percussion in his fantasy All Time Orchestra.

After leaving the Sammy Stewart Orchestra in the early 1920s, Earl Hood formed his own band to play at Indianola Park. His brother Ray had his own Hood-Pendleton Orchestra before deciding to leave the music business. Hood always credited his band's popularity to a lesson he learned working after school in his father's store across from F. and R. Lazarus—always give honest measure.

When he returned from the Spanish-American War, Stapleton Wright brought a saxophone with him. Soon he had formed the Wright Saxophone Orchestra, which included Harly Baker, Joe Hickmann, Dorance Stewart, George "Smut" Smith, and Stapleton Wright. This group was on the road much of the time, playing the Midwest college circuit. One of Wright's protégés was band leader Fred Waring.

Dick Fidler's 13-member orchestra played a total of 45 instruments (every member doubled on something). A Valley Dale favorite, Fidler was joined by Austin "Skin" Young for awhile in 1932 when Young was dying from tuberculosis. Fidler was a songwriter as well, penning "Chromatic Rag," "Just Like A Thief In The Night," "Reaching For A Star," and "Shadows."

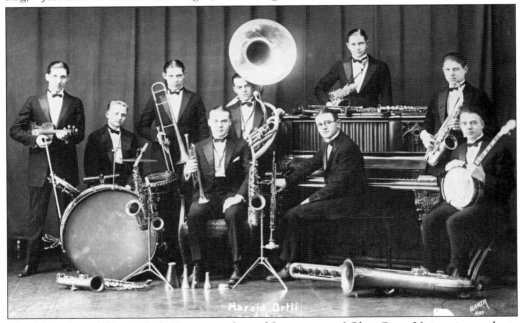

Harold Ortli and His Melody Kings was formed by a group of Ohio State University students around 1924. This was the more sedate version of Harold Ortli and His Ohio State Collegians, which recorded a 78 for Okeh Records. The main difference was the addition of violins to the group. (Jack Smith.)

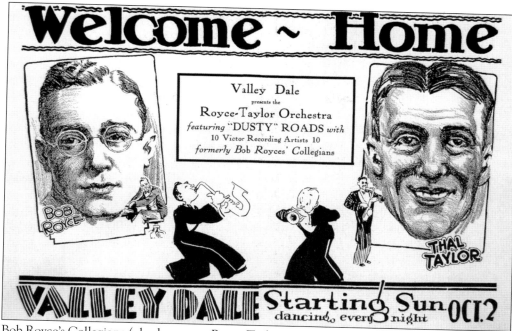

Welcome ~ Home

Valley Dale
presents the
Royce-Taylor Orchestra
featuring "DUSTY" ROADS with
10 Victor Recording Artists 10
formerly Bob Royces' Collegians

BOB ROYCE

THAL TAYLOR

VALLEY DALE Starting Sun OCT.2
dancing every night

Bob Royce's Collegians (also known as Royce-Taylor Orchestra) was formed while most of them were students at Ohio State University. In 1928, bandleader Ted Weems heard them play while he was appearing in Columbus. Coincidentally, there was a revolt among his own band members at the time, so he fired them and hired Royce's musicians to replace them. Many of them were still with Weems when Perry Como joined the band in 1936.

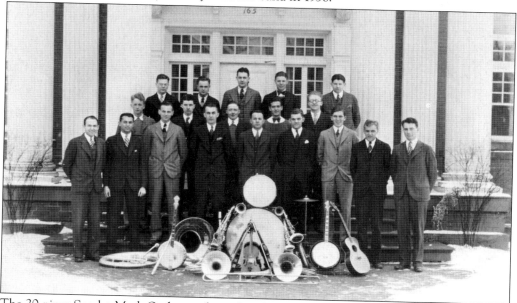

The 20-piece Scarlet Mask Orchestra formed at the Ohio State University to play in support of the original musical productions staged by the theater group of the same name. However, it also led an independent existence as a dance band. During 1928 and 1929, the group became the house band on several cruises of the S.S. *Calgarie* and the S.S. *Leviathan*.

Another Ohio State University student, Jimmy Franck, formed his own group, which served as the house band at Valley Dale for about a year. Subsequently, they were named the best college band in the country, earning an appearance with Bob Crosby and His Bobcats. Julian Bach, writing in the November 1939 issue of *Metronome*, praised Franck's band for its Glenn Miller style.

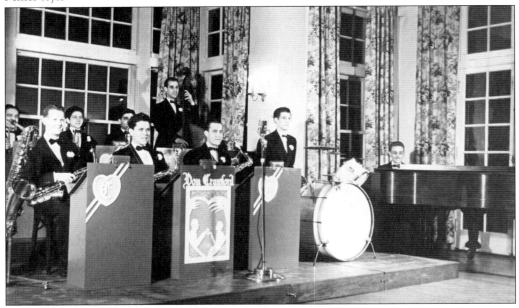

The Don Crawford Orchestra served as an incubator for many young musicians in the central Ohio area. Donley Crawford Hennen, a bank manager by day, always said he started his own band because he could not break into any established ones. Though medically ineligible to serve in the military, Crawford drew many of his musicians from the ranks of the Fort Hayes Base Band.

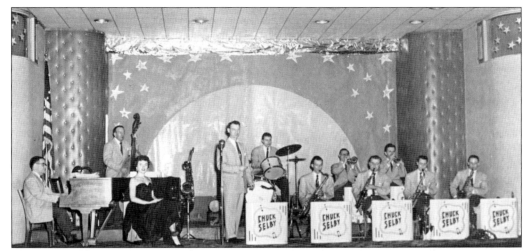

When Chuck Selby decided to start his own band, Crawford told him he could use all of his music and some of his guys. Crawford even played with the band for awhile after he realized his own death was not as imminent as his doctor had led him to believe. Selby had actually formed his first band back in 1932 and led the Curtiss-Wright Jive Bombers during the war.

In 1949, Howard Mauger's Orchestra was used for the Young Business Man's Club shows. However, in the mid-1930s, he had a big band that featured three trombones, a first for the Columbus area. Mauger was forced to write his own arrangements because there were not any stock arrangements for this configuration. As a result, Charlie Spivak tried to hire him as an arranger and trumpet player.

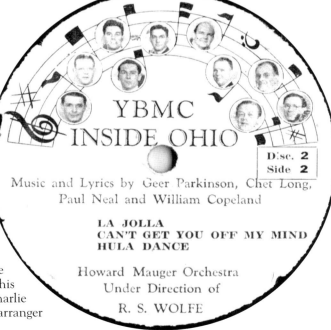

YBMC INSIDE OHIO

Disc. 2
Side 2

Music and Lyrics by Geer Parkinson, Chet Long, Paul Neal and William Copeland

LA JOLLA
CAN'T GET YOU OFF MY MIND
HULA DANCE

Howard Mauger Orchestra
Under Direction of
R. S. WOLFE

41

Lou Posey was a Columbus theatrical agent who put together several groups under his own name, such as Lou Posey's Ambassadors. Posey ran an entertainment agency in conjunction with John Moore, which became one of the biggest such enterprises in the Midwest, handling the bookings for many state fairs.

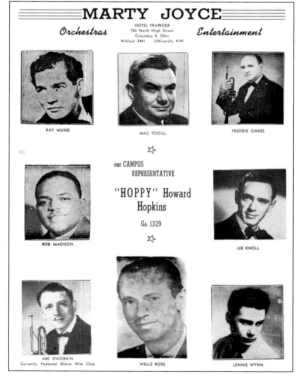

In the 1940s, Marty Joyce booked many local bands, including those of Ray Mund (Klingbeil), Mac Tooill, Freddie Oaks, Bob Madison, Lee Knoll, Abe Dworkin, Wells Ross, and Lennie Wynn (Leonard E. Wolstein). Since many of the jobs were for college events, fraternity parties, proms, mixers, and so on, the bands were largely composed of college students.

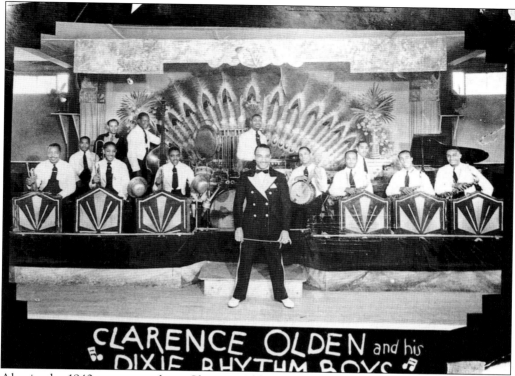

Also in the 1940s, trumpet player Clarence Olden brought his Dixie Rhythm Boys, including vocalist Clarence "Chick" Carter, from Cincinnati and never left. Eventually, he renamed his group the Clarence Olden Orchestra. When he retired, Emile Leon took the band over and renamed it the Emile Leon Orchestra. King Records's star Earl Bostic was once a member of Olden's band along with trumpeter Jonah Jones.

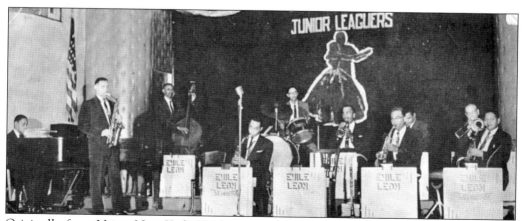

Originally from Utica, New York, Emile Leon was a member of the Tuskegee Airmen who wound up being stationed at Lockbourne Air Force Base. After working with Percy Lowery, he formed the Keynotes of Rhythm before joining the Clarence Olden Orchestra. This led to the formation of Emile Leon and His Orchestra in the 1950s.

Cal Greer brought his orchestra to Columbus from Huntington, West Virginia, around 1939 to play the Alhambra. They then became the house band at the American Legion hall. The star of Greer's band was tenor sax player Jimmie Allen, who is said to have never lost a "cutting session." Pianist Eugene Vann "Piano Man" Walls, who went onto a lengthy career with Atlantic Records, also was a member.

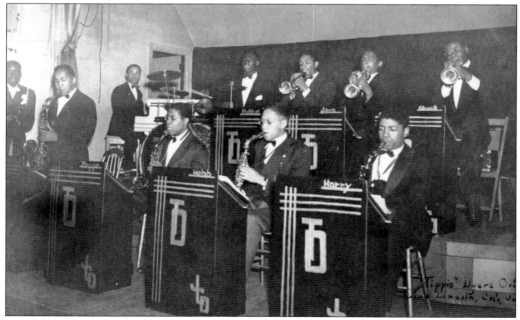

The Tippie Dyer Orchestra started as a Works Progress Administration youth orchestra under the direction of Peter France. However, in the early 1940s, trombonist Dyer took over the leadership of the group and moved it from Beatty Recreation Center to the Lincoln Theater. This photograph is one of the few showing the inside of the Lincoln Theater.

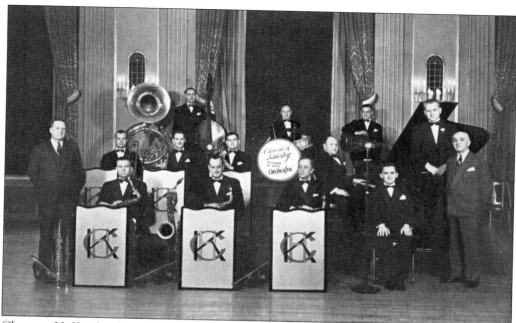

Clarence H. Knisley, born in Ross County, was secretary of state from 1937 to 1939 and lived in Columbus for at least a decade afterwards. During his term of office, he also fronted his own orchestra. Knisley ran for governor twice, as well as auditor, but lost to John McSweeney and Frank J. Lausche.

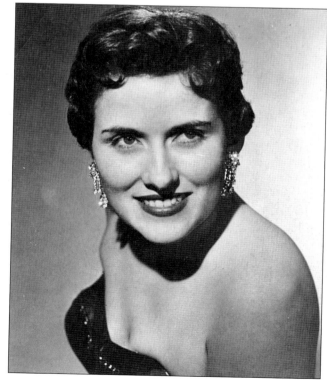

Anne Young (originally Youngblood) became a big band vocalist while still a high school sophomore in Marion. She sang with the campus band while attending Ohio Wesleyan University then moved to Columbus where she became a featured vocalist on the *Spook Beckman* television show in the mornings and with the Chuck Selby Orchestra in the evenings.

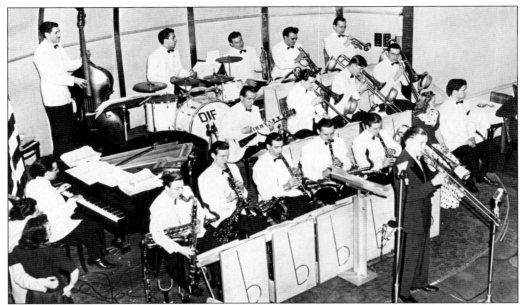

When the Dorsey Brothers had their famous feud, Jimmy Dorsey wound up picking 16-year-old Bobby Byrne from nearby Pleasant Corners to replace his brother Tommy on trombone. After a few years, Byrne was fronting his own big band in New York City before serving as a flight instructor during World War II. Later he became a producer, arranger, and session player for Command Records.

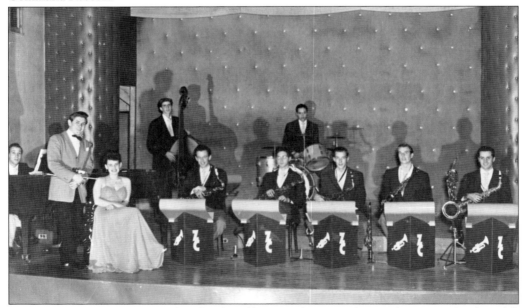

A proud graduate of West High School, William Coyle was nicknamed "Ziggy" after his idol, trumpeter Ziggy Elman. After graduating from Ohio State University, he headed to New York City only to discover "every trumpet player I saw was better than me and half of them were out of work." Returning home, he started his own band and launched what became the largest chain of music stores in the state.

The product of a show business family going back to the riverboat days, Patricia Wilson starred in Strollers productions at Ohio State University, appeared on many WBNS-TV programs, and sang with the George Towne Orchestra before landing on Broadway in the early 1950s. She also was cast as Trixie, Ed Norton's wife, when Jackie Gleason moved production of *The Honeymooners* television series to Florida. (Pat Wilson.)

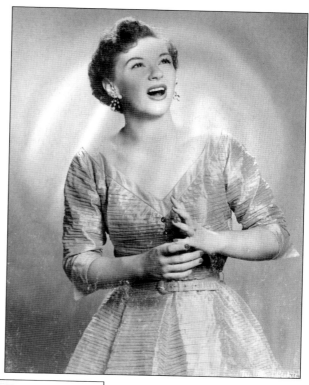

When Wilson left the George Towne Orchestra for Broadway, the widely traveled Kiki Paige replaced her as the band's vocalist. She not only sang and danced but also rode the unicycle, which explains the title of her autobiography, *Kiki On One Wheel*. After singing in several other local bands, Paige went off to work as an entertainer in Las Vegas. (Chuz Alfred.)

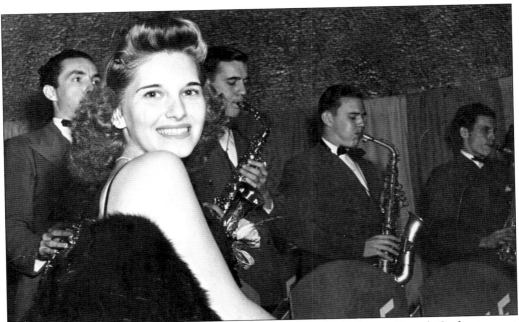

Peggy Parr was one of a number of vocalists associated with the Jimmy Franck Orchestra over the years. Others during the late 1930s and early 1940s included Sue Coulter and Patty Cooper. Franck went on to play in Nelson Riddle's band during World War II then resumed his band leading when he returned to civilian life.

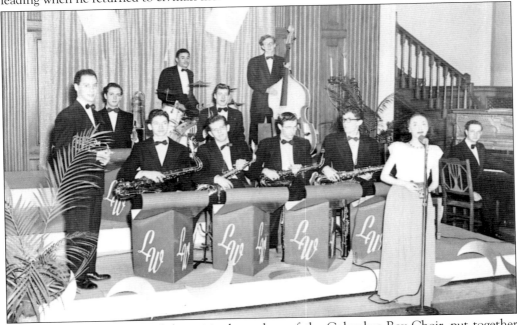

Leonard E. Wolstein, one of the original members of the Columbus Boy Choir, put together Lennie Wynn and His Orchestra, a 10-piece band, when he was still in high school. After graduating from Capital University, Wolstein became a leading music copyist in Hollywood, working on many major motion pictures and all of Aaron Spelling's television productions.

Four

THE BIG BROADCAST

The first radio station in Columbus—WEAO (Willing, Energetic, Athletic Ohio)—began broadcasting from the Ohio State University in April 1922, the same year that KDKA, the first commercial station, signed on in Pittsburgh. The first program at WEAO included baseball scores, a report on a local fire, and recorded music. However, it was not long before live music, both in the studio and from remote locations, became the norm.

In those days, few musicians were paid to perform on radio; they did it for free in order to promote their live appearances at clubs, dance halls, armories, and so on. However, the response to one local group, the Musical Notes, was so great that they soon landed a sponsor, Texas Mineral Water Crystals, and a regular slot on the *Hi, Neighbor* show every morning at 6:30.

People from all walks of life found themselves with second careers on the radio, though most wisely kept their day jobs. Two Columbus police officers, detective Glenn Hoffman and patrolman Leo Phillips, were the Singing Coppers on WCAH. Ellsworth Whipps was Duke and his Uke on WSEN. Ruth Kelly, Mae Canning, and Betty Cannon, accompanied by Naomi Burrows, were called the Three Shades Of Blue, and were spotlighted on WCAH.

While WAIU/WHKC leaned toward country-western programming, WBNS (an affiliate of CBS) was dance-band oriented and often originated from the Ionian Room in the Deshler-Wallick Hotel or other popular spots. Competition for listeners was fierce, formulas were nonexistent, and almost any idea was worth a try.

Steubenville's Dino Crocetti arrived in Columbus in 1938 or 1939 and was hired as a singer by bandleader Ernie McKay who renamed him Dino Martini. Initially sharing the bill with Terry's Six Wonder Dogs, Martini was heard twice daily from the State Restaurant over WCOL before joining the Sammy Watkins Orchestra in Cleveland, where his name was anglicized to Dean Martin. Radio was reaching its zenith.

Then during a six-month period in 1949, Columbus's three very high frequency (VHF) television stations, WLW-C, WTVN, and WBNS, signed on the air. No other VHF stations have been added since. Pundits who described television as radio with pictures were not far off, since many shows in the early days were simply reworked radio programs.

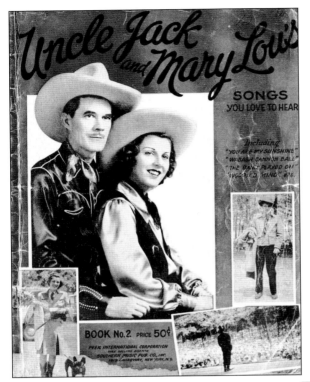

Uncle Jack [Nelson] and Mary Lou were both from small towns in Ohio, the former from Buchtel and the latter from Patriot. They got their start at WAIU radio in Columbus around 1928 then moved onto various other stations in West Virginia, Pennsylvania, Maryland, North Carolina, and eventually Florida during the winter.

In 1930, Harry Hoesley, the general manager of WAIU, was casting about for a way of generating greater interest in his station. He took a popular husband and wife knife-throwing/sharpshooting carnival act, surrounded them with musicians, and gave birth to Montana Meechy's Cowboy Band. Meechy was a veteran of Buffalo Bill's Wild West show until it closed in 1917.

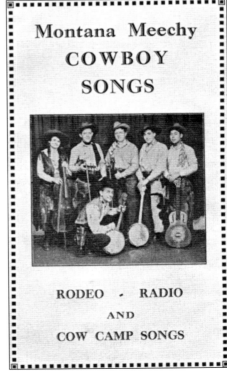

At the age of five, Ethel Mae Thompson was a featured performer on local radio as one of a troupe of "Klever Kiddies." She remembers that the announcer was so tall that she could run between his legs, so she nicknamed him "Daddy Longlegs." Ten years later, she was singing with the Chuck Selby Orchestra under the name Jeanne Bennett. (Jeanne Cummins.)

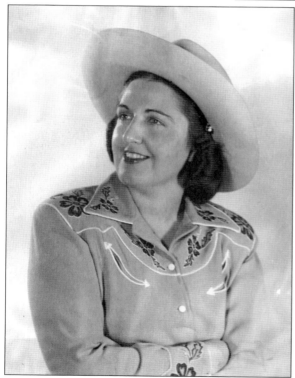

Grandview Heights High School student Donna Albanese auditioned for WAIU radio in 1933 and quickly found herself the star of a Saturday morning show, *Songs by Donna Albanese*. Unlike most of the musical acts carried by WAIU, she sang modern songs; however, she "changed her tune" after she married cowboy singer Hank Newman. (DN.)

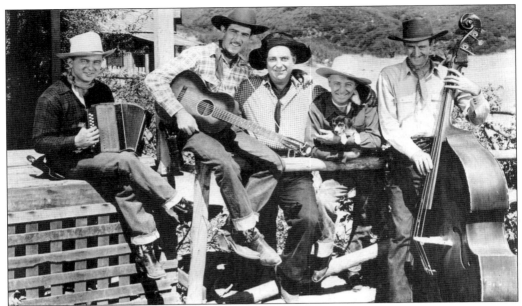

Among the most successful radio stars were Hank, Slim, and Bob Newman—the Georgia Crackers—who, with Al Myers (guitar) and Johnny Spies (accordion), were heard over WAIU (which became WHKC and finally WTVN) for 22 years. Their program was carried coast-to-coast on 484 stations every Saturday morning by the Mutual Network, and they also made movies. This is a still from *Desert Vigilante* with Smiley Burnett. (DN.)

Many other local performers were featured by Hank on radio and in live performances, including singer Janie Swetman. Donna Newman recalls that Swetman had an exceptionally beautiful voice and was able to alter her style to fit any material. She was only 10 or 11 when she first joined the show. (DN.)

Sponsored by Tip Top Bread, fiddler Jimmy Weiner led the Tip Top Rangers, which included Bob Edgington, Donna Jean Spies, Myers, and Ted Sego, among others. They performed on the Georgia Crackers's regular radio broadcasts. Weiner later operated the Tip Top Club on North High Street. Myers is regarded as a pioneering country guitarist just after Chet Atkins and Merle Travis. (DN.)

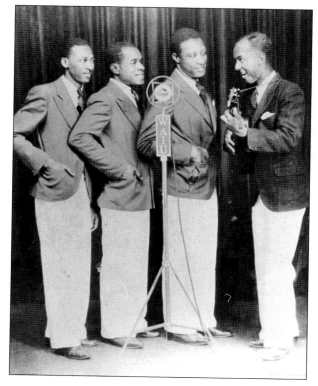

Several black vocal groups also graced the local airways, including the Imperial Four (Floyd Lewis, Samuel Hendricks, Cleo Combs, and Leroy Bowen) from 1931 to 1938. Bowen recalls broadcasting from the 19th-floor studio in the American Insurance Union Citadel (the Lincoln-Leveque Tower) when a violent storm caused the building to sway, sloshing the water in the toilets.

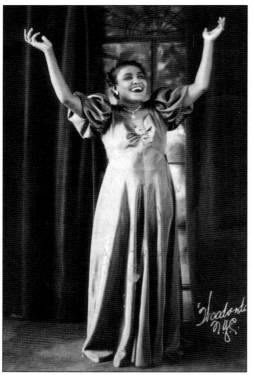

Soprano Ruby Elzy was first heard over WEAO while she was still a student at the Ohio State University. Her remarkable rise from abject poverty in Mississippi to creating the role of Serena in the original Broadway production of *Porgy and Bess* has been chronicled by David E. Weaver in *Black Diva of the Thirties: The Life of Ruby Elzy*. (David E. Weaver.)

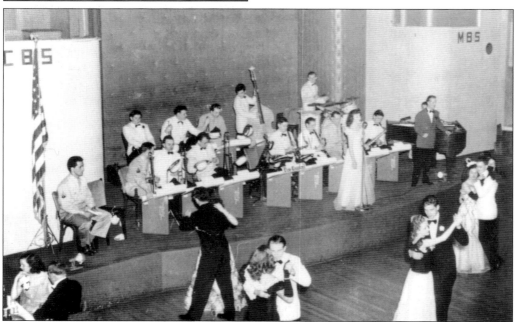

Historic Valley Dale ballroom holds the distinction of being the only venue in the country that simultaneously housed broadcast booths for two competing networks, CBS and MBS. Originally built as a stagecoach stop, Valley Dale continues to host musical events and private parties under the longtime ownership of the Peppe family.

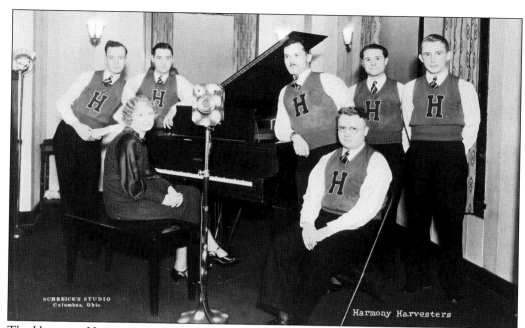

The Harmony Harvesters were one of many forgotten groups that used to perform on Columbus radio during its pioneering days. Honey Holsten, William Oger, and the Theronoid Hawaiians are examples of other local radio stars who had a major following in the 1930s but were soon forgotten as listeners became more sophisticated and demanding.

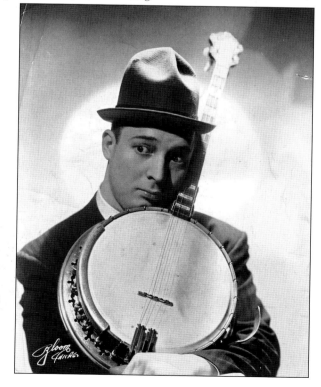

Best remembered as the mute Bernardo in Disney's *Zorro* television series, Gene Sheldon got his start at the Knickerbocker Theatre as part of his father's magic act, playing a female assistant. An accomplished banjo player and singer, he worked on radio in Toledo before winning a talent contest in New York and going on to stardom on stage and screen.

Howdy Kempf, a farm boy from Richland County, formed his first working band when he was 15. He soon was heard over WATG radio in Ashland six days a week, not including an hour-long special every Saturday evening. The one-time square dance caller soon found himself as a regular on WWVA's Jamboree, appearing with the Georgia Crackers and later with the Al Myers Quintette four times a week on WHKC radio. (DN.)

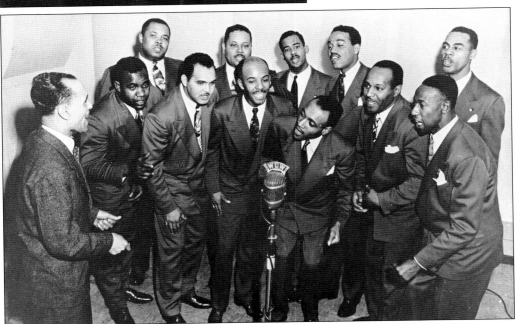

Formed by a group of Curtiss-Wright aircraft employees during World War II, the Harmonaires were quickly tapped as company ambassadors and embarked on a United Service Organizations (USO) tour of hospitals and military bases. Along the way, they earned frequent guest spots on the Henry Morgan, Ed Sullivan, Paul Whiteman, and Fred Allen radio shows in New York City.

The "queen of the Broadway flops," Susan Johnson started her career on Columbus radio when she was three. The day she turned 20, she landed a job in the chorus at Radio City Music Hall and the following year was cast in *Brigadoon*. Although she starred in a number of other Broadway musicals, her only true hit was *The Most Happy Fella*.

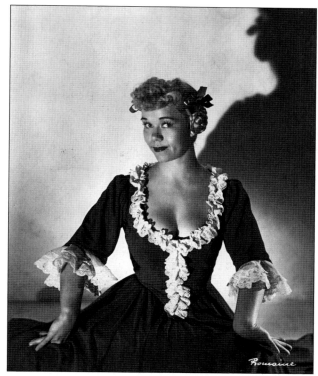

Herbert Huffman founded the famous Columbus Boychoir in 1937 and remained with the organization for six years after it moved to Princeton, New Jersey, in 1950. During his tenure, the group recorded for RCA and Decca, supplied the lead for the annual televised performance of Menotti's *Amahl and the Nigh Visitors*, and became world famous.

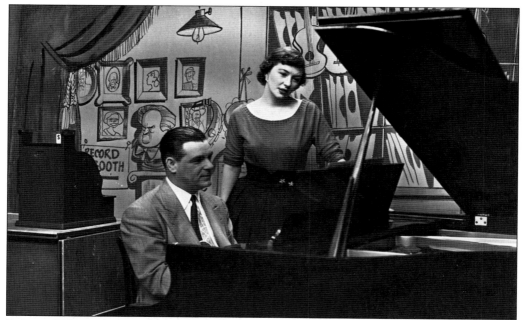

Patricia Wilson, shown with pianist Roger Garrett, had her own show, *The Melody Shop*, on WBNS-TV in 1950. However, the bright lights of Broadway were beckoning. Soon Wilson was originating the leading role of Marie in the musical *Fiorello!*, earning a New York Drama Critic's Circle nomination for best actress. Numerous television and film roles followed. (Pat Wilson.)

Chuck Selby "was always optimistic and personable," according to violinist Randall Near. "He could make just about anything work out." He organized his first band in 1932 and was still going strong up until he passed away 46 years later. At that point, he had been managing Valley Dale ballroom for 25 years.

Jeanne Bennett had just turned 18 when she was asked to join the Bernie Cummins Orchestra. Although the musicians were prohibited from dating their featured vocalist, Bennett wound up marrying the band's guitarist (and Cummins's brother), Walter. As Jeanne Cummings, she was seen daily over WLW-C on the *Dean Miller* and the *Spook Beckman* television shows.

I WOULDN'T DO IT
—for the WORLD

WORDS *by*
CHESTER RICE
MUSIC *by*
GEER PARKINSON

Successfully featured by
GEER PARKINSON·WAIU·*Organist*

JOE McDANIEL MUSIC CO.,
"SONGS THAT APPEAL"
CHICAGO NEW YORK

During World War II and shortly thereafter, WBNS radio aired its own version of WLW's *Moon River* broadcast, drawing on the talented organ-piano team of Geer Parkinson and Paul "Snook" Neal. With Parkinson at the theater-sized pipe organ and Neal at the seven-foot Steinway, they reviewed the popular tunes of the day as well as a sampling of the then current Broadway musicals from the ninth-floor studios at 33 North High Street.

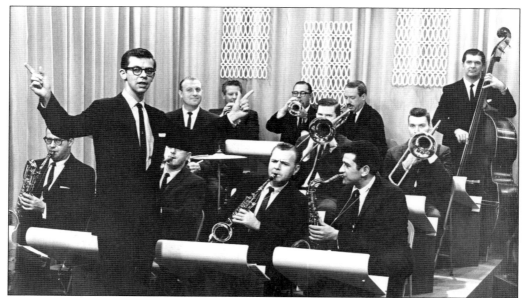

Pianist, arranger, and composer Al Waslohn had attended the Eastman School of Music and studied with Jose Iturbe, Fritz Reiner, and Leonard Bernstein, to name a few. He became music director at WLW-C TV in the early 1950s and led the band that was heard (and often seen) on the live programming during that era. Waslohn recorded with Buck Clayton and Jimmy Dorsey.

Seen here from left to right, Charlie Cesner, Sally Flowers, and Gene Fullen were fixtures on Columbus television during the 1950s. Cesner was a popular organist who worked in clubs and at Al Haft's wrestling matches. Flowers got her start in a vocal trio, the Three Belles, before becoming a television hostess. Fullen was equally at home on radio and television, entertaining teens at sock hops and housewives on a variety of television programs. (DN.)

At the age of 15, singer Nancy Wilson entered a talent contest sponsored by WTVN-TV, which led to her own television show, *Skyline Melody*. Graduating from West High School in 1954, Wilson worked with a number of local bands before heading to New York. Within a few months, she was signed to Capitol Records. A half century later, Wilson is still going strong, having released more than 50 albums.

Margie Alden began singing as a child in the 1930s. During World War II, she worked with many local bands, including those of Don Crawford, Chuck Selby, Bob Marvin, and Ziggy Coyle (whom she married in 1956). Her career has included singing on radio and television as well as being the featured vocalist with Dr. Robert Everhart's 36-piece orchestra.

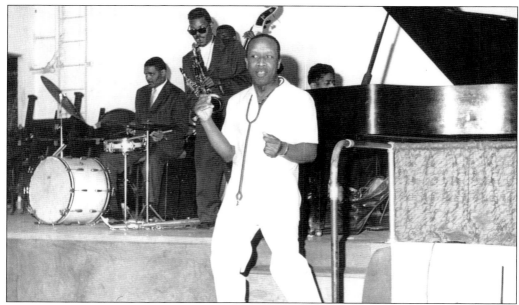

Hoyt Locke, better known as "Dr. Bop," was a legendary Columbus deejay of the late 1950s and early 1960s. Known for his hip patter ("This is Dr. Bop on the scene with a stack of shellac for his record machine!"), Locke introduced many white teenagers (and maybe a few black ones as well) to the sounds of rhythm and blues. Here he is seen with young Ronald T. Kirk. (Kojo Kamau.)

During the 1950s and 1960s, WLW-C (now WCMH) television had a live morning show. The hosts included Dean Miller (from the popular television sitcom *December Bride*), Nick Clooney (actor George Clooney's father), Jack Denton, and the ever-popular Spook Beckman. Al Waslohn led the band and Jeanne Cummins was a featured vocalist.

Five

THE RISE OF THE VOCAL GROUPS

The first male quartets singing in the barbershop style date back to the dawn of the 20th century, if not before. In 1910, Lewis F. Muir wrote, "Play That Barber Shop-Chord," a song that was closely associated with the great Bert Williams but was also recorded by Billy Murray, among others. In truth, the a cappella, four-part harmony technique probably does have its origins in the barbershop. It also is believed to have started in the African American community, although black barbershop quartets are quite uncommon nowadays. However, Raleigh Randolph once sang in the Four Suntanned Gentlemen from Georgia, a black barbershop quartet from Ohio.

"Columbus has always been known for its vocal groups," Leroy Bowen of the Harmonaires once said, but that begs the question, "By whom?" While there have been many outstanding vocal groups in central Ohio, the average person on the street probably could not name one. The fact is that opportunities for pure vocal groups to perform have never been plentiful. For one thing, they are usually dependent upon a back-up band unless they are strictly a cappella. For another, club owners are seldom interested in paying for both a vocal group and a band.

The Four Dukes are a good example. Formed in 1952, they modeled themselves after the Swallows and picked up jobs here and there in area clubs. Hoping their luck would change, they hitchhiked to California and within a few months had the opportunity to cut a record for Art Rupe's Specialty label. One 45 was released from the session, "Ooh Bop She Bop" backed with "Oh Kay," but the Four Dukes failed to land a single gig during the five months they were there. They drifted back to Columbus and broke up. Few knew they had been away.

Nevertheless, as a number of national vocal groups started placing songs on the charts, Columbus responded. It was a rare high school that did not have at least one quartet or quintet vocalizing in a restroom or stairwell to take advantage of the acoustics. The era of the street-corner symphony was brief, but from the recorded evidence, the quality was high. In fact, 45s by Columbus groups are among the most highly sought after by collectors. Far more common was the combination vocal and instrumental group.

In a way, the Vallejos, the Supremes, the Four Pharaohs, and many others were children of the Harmonaires. There had been other vocal groups before the Harmonaires, but "Allen's army" (as radio's Fred Allen dubbed them) were the ones who blazed the trail for other Columbus groups, combining nightclub performances, radio broadcasts, recordings, and even a film appearance in a career that spanned four decades.

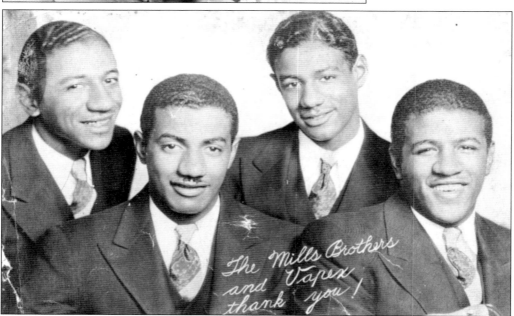

Two major influences on the Harmonaires had ties to Columbus. Piqua's Mills Brothers originally came to town in the 1920s. They sought out Lou Peppe at Valley Dale and asked him to manage them, but he did not have time. So they wound up singing on a platform outside a bar on Riverside Drive. Eventually, they found their way to Cincinnati, where they began performing on WLW radio.

The other major influence on the Harmonaires was the Ink Spots from Indianapolis. The Mills Brothers, the Harmonaires, and the Ink Spots were featured on WLW radio at various times before heading to New York. In 1952, Ink Spots lead vocalist Bill Kenny tapped Ernie Brown to join his new incarnation of the quartet. Subsequently, Brown lived and performed in Columbus for many years. (Brown family.)

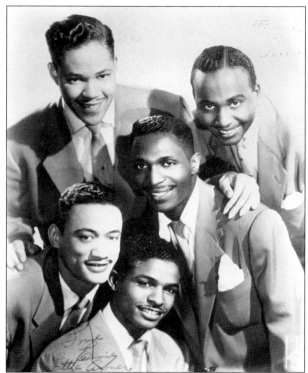

In the early 1940s, George Chamblin and Safford Taylor attended a barbershop quartet concert in Cleveland and became instant converts to this dying style of harmony singing. Returning to Columbus, they enlisted Rodger "Dodge" Harris and Morton (Mort) Bobb, fellow Phi Gamma Delta fraternity members, to form the Buzz Saws. When Harris and Bobb dropped out in early 1947, they were replaced by Bruce Lynn and Paul "Snook" Neal.

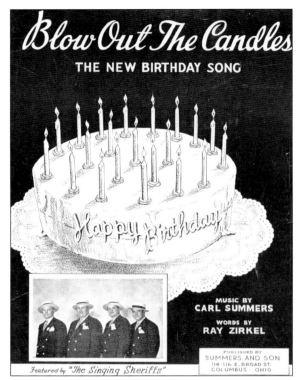

The Singing Sheriffs members Harry M. Freeman, Fred Hawkes, Ray Hathway, and Fred "Dixie" Washburn, also known as the Buckeye Songbusters, participated in barbershop quartet events but were not a barbershop quartet in their approach to vocal harmony. "Blow Out the Candles" (actually recorded by the Harmonaires) was an attempt by local songwriters Carl Summers and Ray Zirkel to get in on the lucrative birthday song money. The Singing Sheriffs was in existence from the late 1920s to at least the late 1950s and at one time or another included Jack Everett, Robert Willison, Billy Everett, Orland Everett, Hal Chenoweth, Therrel Trimme, and Paul F. Berger. During the 1930s, they were in competition with the Singing Coppers of the Columbus Police Department.

Composed of three real (Eugene, James, and Charles Strider) and one "honorary" brother (James Griffin), the Striders began performing on their mother's front porch prior to World War II and soon found work in local clubs. After recording for several other labels, they switched to Manor and became Savannah Churchill's backup group. They are shown here in the 1949 film soundie "Mississippi Flyer."

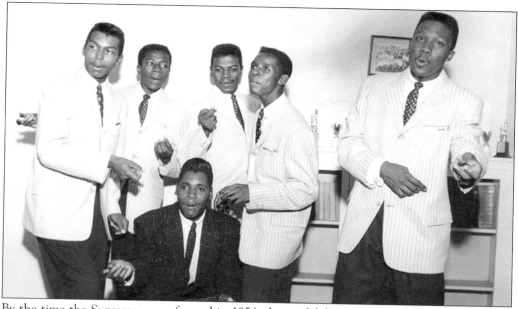

By the time the Supremes were formed in 1954, the model for many vocal groups had become the Drifters. Composed of East High School students, the Supremes went on the road and were "discovered" singing at the Southland Club in Pensacola, Florida. Quickly signed to John Vincent's Ace Records, they recorded three songs at Cosima Matassa's studio in New Orleans, backed by Huey "Piano" Smith's band.

The Vallejos formed at East High School then added Kynne Winston from Central High School. They enjoyed considerable success locally, even landing a spot on Dick Clark's Cavalcade of Stars when it played Veteran's Memorial auditorium. Signed to Vee Jay Records, they were billed as the Lyrics for their first release and the Falcons for their second to kick off the new Falcon label.

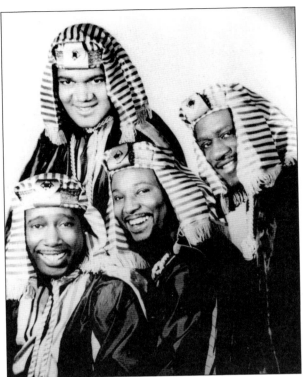

Another vocal group that brought together East and Central High School students was the Four Pharaohs. Over time, they evolved into King Pharaoh and the Egyptians and, finally, the Egyptian Kings. The only constant was Morris Wade. One member of the group, Bobby Taylor, had a hit record with his Motown group Bobby Taylor and the Vancouvers.

Among the other members of King Pharaoh and the Egyptians were Johnny McDaniel, Ronnie Taylor (Wilson), George Smith, Bernard Taylor (Wilson), Bob "Pee Wee" Lowery, Pete Oden, Forest Porter, Paul Moore, Leo Blakely, William Suber, and Sylvester Moore. Guitarist Harold Smith was King Pharaoh.

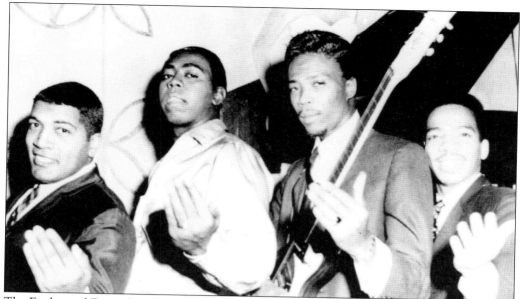

The Enchanted Five released one 45 in 1961: "Have You Ever" backed with "Try A Little Love." They were led by Earl R. Riley and included Donnie Scales, who was in the Segments of Time a decade later and a gospel singer after that, and Jimmy Rafford, who joined the re-formed Four Mints in 1990.

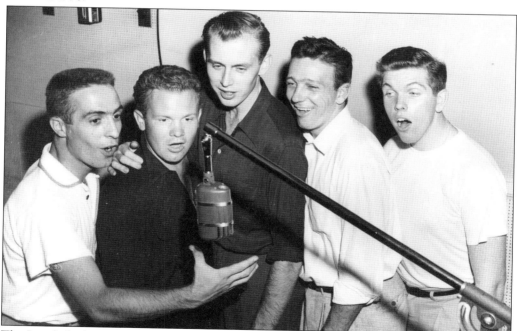

The Interludes began with Ray LaMacchia, Thommy Thompson, Al Evans, Ron Carlson, and Dick McClure. Ian Polster, Gene Allar, and Betty Saint were later members of this vocal and instrumental group, which played the New Latin Lounge, Roxy Club, Kitty's Show Bar, and similar venues in the 1950s and 1960s. They also drove a hearse that had slogans painted on it such as "Put Life In Your Parties." (Chuz Alfred.)

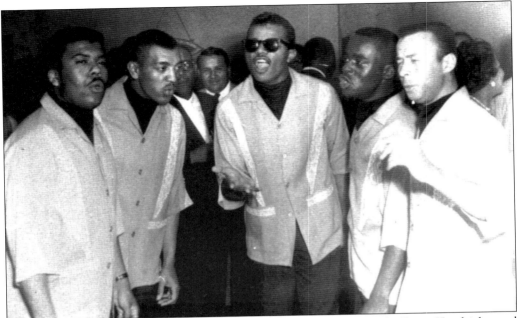

The Five Dreamers were Ernest Mackey, Jesse Williams, Charles Smith, Corey Kendricks, and Albert "Stoney" Stoner. They toured in the east in 1955 under the direction of orchestra leader William "Jimmy" Allen. They eventually were known as just the Dreamers. Bobby Taylor, who later formed Bobby Taylor and the Vancouvers, also passed through this group.

The Varsitones were a vocal group that worked with Howdy Gorman's Ohio Staters Orchestra. The members in 1956 were Roger Harris, Jeri Parker, Don Zimmerman, Sue ?, and Ray Racle. Gorman, who was a booking agent and had been in music for at least 20 years at this point, was a very short individual and many of his publicity photographs emphasized his diminutive stature.

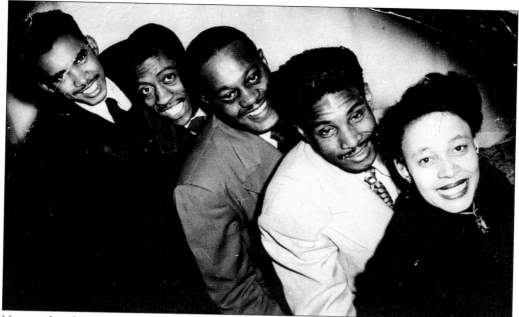

Not much is known about this vocal and instrumental group. However, during 1953 and 1954, Pete Burkham, Lew Hughes, George Crowder, Tommy Gibbs, and Betty Shepperd-Wimbley were the Mellowtones. They should not be confused with Bill Jones and His Mello-Tones, which were in existence at least until 1952.

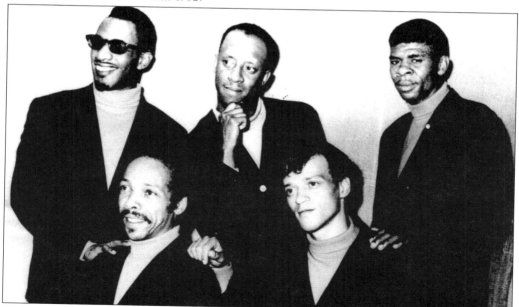

In 1963, producer Phil Gary created one of the more interesting vocal group recordings to come out of Columbus when he paired organist Caleb Talbot and the Emporers, a group whose membership seems to have been rather fluid, on "I'm Yours" backed with "See About Me." He called the result Caleb and the Playboys, but by all accounts it was not typical of the type of material Talbot usually did.

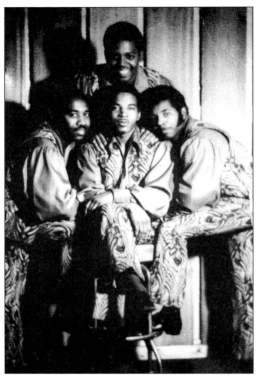

Benjamin "Pete" Caldwell of the Falcons and Donald "Duck" Russell of the Matadors joined with James Brown of the original Five Mints and Jimmy Harmon from West Virginia to form the Four Mints. Deejay Bill Moss initially recorded them on his Holiday label then made them the stars of his more ambitious Capsoul label. He felt they were "good enough for Vegas."

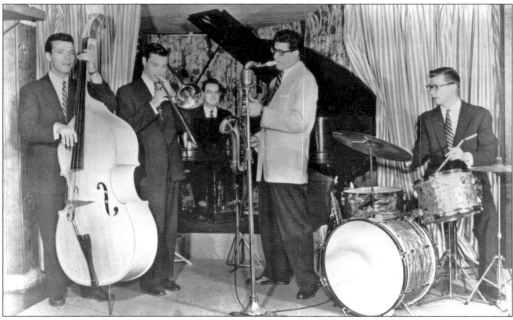

Although not primarily known as a vocal group, the Chuz Alfred Quintet was based on a shared vision of three-part horn charts and four-part (four freshman-style) vocals. However, Alfred feels that the group's versatility led to its downfall because they failed to establish a sound of their own. They were more jazz oriented than a group such as the Interludes. (Chuz Alfred.)

A vocal-instrumental quintet from the mid-1960s, the Embers consisted of Dick Stoltzman, Bob Porce, Bill Bailey, Sid Townsend, and the future founder of the Jazz Arts Group, Ray Eubanks. They played the Grandview Inn. Eubanks designed the Capital University Music Conservatory's Jazz and Music Industry programs and taught trumpet for more than 25 years.

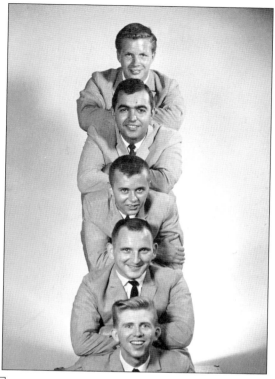

By his own admission, Phil Gary (Sciamamblo) was never a great singer. However, at age 16, he was already a promoter. Inspired by watching Freddy Cannon lip-synch "Tallahassee Lassie" on *The Dick Clark Show*, he cowrote a song with his mother called "Bobby Layne" and recorded it in a basement with a group of guys (Harry Smith, Rick Guyton, and later, Phil Stobart) he named the Catalinas. (Phil Gary.)

Phil Gary booked Veterans' Memorial in 1961 for what he called the Battle of the Groups. In addition to Phil Gary and the Catalinas, those that competed included the Carians. Gary eventually persuaded Phil Stobart of the Carians to join the Catalinas, but he still considers the Carians to have been the best of all the local groups. (Phil Gary.)

Phil and the Catalinas frequently worked record hops with Dave Logan of WTVN radio. Gary attributes the popularity of the group to the fact that each of the members attended a different high school. Rick Guyton attended Grandview Heights, Harry Smith attended Aquinas, Stobart attended Central High School, and Gary attended Bishop Watterson, where he was also captain of the basketball team.). (Phil Gary.)

Six

HONKERS, SQUAWKERS, AND BAR WALKERS

With their ranks depleted by the draft, the big bands struggled just to get by during World War II. Little did they realize that they carried the seeds of their own destruction with them—pop singers. Once the public shifted their focus to the Sinatras and Bennetts and Clooneys, the musicians who backed them were destined for anonymity. From an economic standpoint, the concept of a big band was, with few exceptions, no longer sustainable. At the same time, some players began forming small combos to play a new style of jazz that was the polar opposite of pop—bebop. Still others discovered a growing audience for "jump" music, or rhythm and blues. Eventually, rhythm and blues was repackaged as rock 'n' roll.

By about 1950, Columbus, like most cities in the United States, was racially divided to some extent. African American musicians often played venues that they were not allowed to patronize or, if they could, only on special nights or when restricted to specific seats. Archie "Stomp" Gordon defended himself in a local newspaper for performing in a club that did not admit blacks, arguing that, in his own way, he was advancing the cause of civil rights.

Nevertheless, by the early 1950s, white and black musicians had begun finding one another. "Salt and pepper" groups began to spring up. Many white musicians got their start playing at Gordon's jam sessions on Barthman Avenue in the south end. On the other hand, Janie Turner, who started with Royal G. "Rusty" Bryant, became one of the first African American singers to front an all white band when she joined nationally known Herbie Fields.

With the decline of the big bands, nearly any club or restaurant could become a musical venue. High, Broad, and Main Streets, and Mount Vernon and Parsons Avenues all became vibrant musical showcases, featuring both national and local acts. As competition increased, the bar owners looked for some gimmick to set their establishment apart from the others. Lou Wilson happened upon the best gimmick of all when Bryant and the Carolyn Club Band scored a major hit with their double-time version of "Night Train."

As a consequence, Columbus nightlife flourished in a way it never had before or since. In addition to Bryant, Nancy Wilson, Rahsaan Roland Kirk, Don Patterson, and Hank Marr were just a few of the local stars who soon broke nationally.

At the age of 13, Archie "Stomp" Gordon was already something of a local celebrity. His precocious talents as a singer and piano player were displayed before such diverse audiences as the Nelsonville Eagles Club, Lafayette High School (London), and Wilberforce University. In his all-too-brief career, Gordon appeared on Ed Sullivan's *Toast of the Town*, made several movie shorts, and accompanied Billie Holliday on an Alaskan tour.

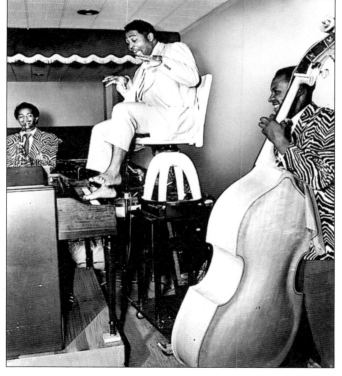

With his bright ties, dice shoe strings, and zebra coat, Gordon was a wonder to behold, especially when he added more power to the bass by stomping on the piano keys with his bare feet (earning him a profile in *Ripley's Believe It Or Not*). The "blues shouter" recorded at least eight singles on four or more different labels. He died at the age of 26.

Born in Richmond, Indiana, alto sax player Sammy Hopkins toured with several big bands, notably Lucky Millinder, Ethel Waters, and Chic Carter. In 1938, he settled in Columbus, where he became a mentor to many central Ohio musicians. He is shown here flanked by Bill Ray (left) and Wendell Hawkins. Hopkins performed for 74 years.

Charles "Chuz" Alfred got his start in the Lancaster-based family band, the Alfred Melody Syncopators, which also produced trombonist Fritz Hummel. Initially, he played clarinet but soon switched to sax. He gave up music briefly while attending Miami University but could not resist an invitation to fill in for an absent horn player at the Sportsman Bar in Hamilton. Soon, he was fronting his own band in Columbus. (Chuz Alfred.)

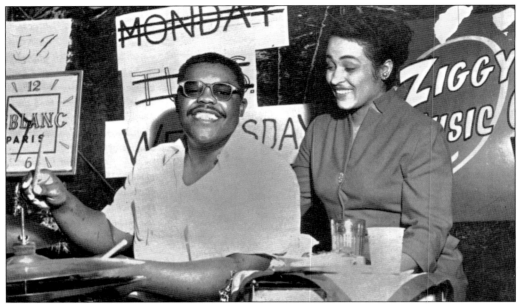

At the age of 26, Jimmy "Stix" Rogers set a world record for marathon drumming—over 80 hours—in the window at Coyle's Music Store. The subject of articles in *Ebony*, *Look*, *Life*, *Time*, and *Downbeat*, Rogers joined Archie "Stomp" Gordon's band at 13, and worked with Royal G. "Rusty" Bryant in the Carolyn Club band. He appeared on *I've Got A Secret*, *What's My Line?* and several other national television shows.

The sister of Harold "Ham" Clark (the longtime accompanist for the Harmonaires), Edith Clark learned how to play piano from her brother. She made her debut in 1947 and soon was rated as "the brightest star on the musical horizon," not only for her musicianship but also for her singing. For several years, she was on the road, playing in Chicago, New York, Texas, and Florida before returning home.

Inspired by Gene Mayl's band in Dayton, Harry Epp formed the Columbus Rhythm Kings in the early 1950s with George Weber, Herman Lehman, Don Blakeslee, and Al Kleiner. They were booked by Lou Posey three nights at week at Roger's on Agler Road and Route 3 (3-C Highway). This band evolved into the Muskat Ramblers. (Chuz Alfred.)

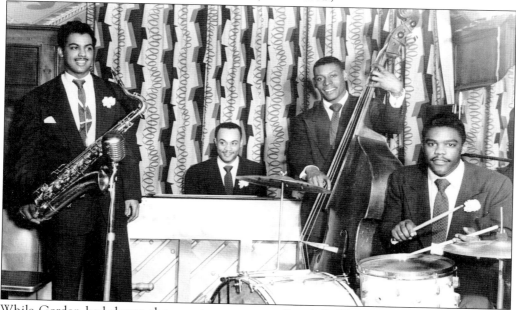

While Gordon had shown the way, tenor sax man Royal G. "Rusty" Bryant kicked the door open with his take-no-prisoners live recording of "Night Train" (renamed "All Nite Long") in 1953. Booked into Lou Wilson's Carolyn Club, Bryant and his band held court seven nights a week while the record gained momentum, eventually breaking across the country. Bryant later recorded a number of highly regarded albums for Prestige Records.

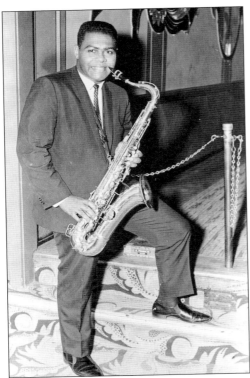

Gene Walker recalls he was "starving" in New York when he ran into his old friend, Archie "Stomp" Gordon, who immediately hired him for the "Ride, Superman, Ride" recording session. This tided him over until he was befriended by fellow sax player King Curtis, who helped him land other jobs, including the Beatles' Shea Stadium concert and subsequent U.S. tour.

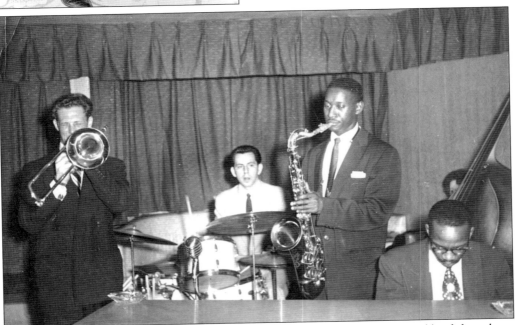

Known to everyone as "P. C.," tenor man Paul Cousar was a disciple of bop, and he did not have the same crossover appeal of many of his contemporaries. Instead, he played primarily "in the 'hood." This version of his quartet dates from the mid-1950s and includes Jim Gary, John Jay, and Paul Marshall. (Chuz Alfred.)

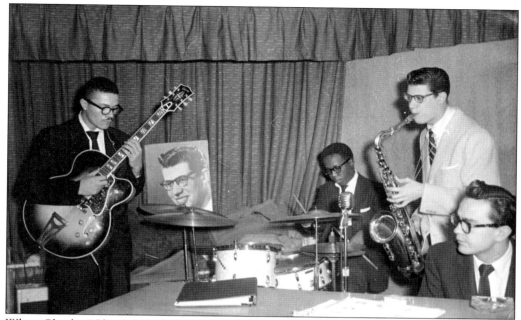

When Charles "Chuz" Alfred played the Macon, his group included Warren Stephens (guitar), Charles Crosby (drums), and Chuck Lee (piano). Both Crosby and Stephens played with Royal G. "Rusty" Bryant as well, which probably led to the idea of a combined Alfred and Bryant all-star band. However, it was not to be. (Chuz Alfred.)

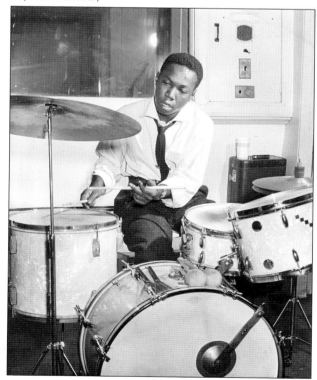

Originally from Memphis, drummer Crosby lived and worked in Columbus for several years in the 1950s, booking acts into the Macon Hotel, where he lived. He had previously worked with Phineas Newborn and B. B. King. While in Columbus, he played in the bands of Alfred, Bryant, and Ronald T. "Rahsaan Roland" Kirk. (Chuz Alfred.)

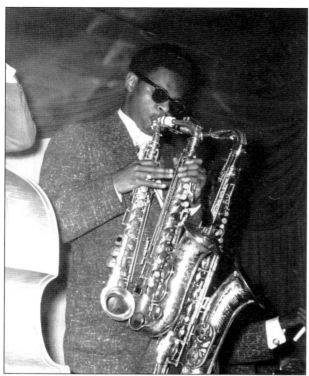

As a young teen, he was simply Ronald T. Kirk, but he was already making a name for himself, besting more seasoned musicians in local talent contests. Soon he was going by Roland Kirk and, finally, Rahsaan Roland Kirk, considered one of the most phenomenal players to ever walk the earth. Although sometimes dismissed as a carnival act, Kirk's stature has steadily increased since his death. (Kojo Kamau.)

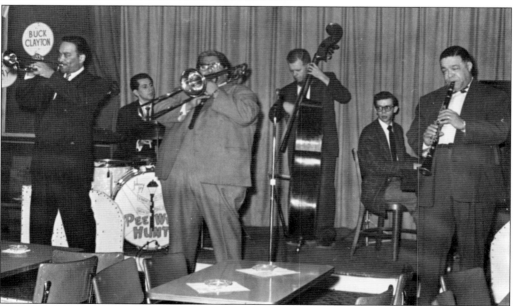

Saints and Sinners was a jazz super group put together by Lou Posey to tour the country. When they played Posey's Frolics nightclub, the band included Buck Clayton, John Jay, Russell "Big Chief" Moore, Pat McKnight, Al Waslohn, and Darnell Howard. Jay was replaced by Barrett Deems, "the world's fastest drummer" and the man Louis Armstrong said "makes coffee nervous." (Chuz Alfred.)

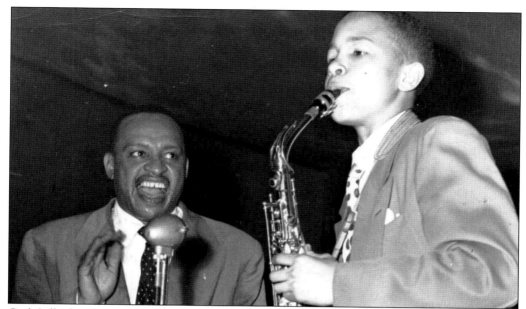

Carl Sally first garnered attention at the age of 12 when he made an outstanding showing in a local talent competition. This photograph was taken when he sat in with Lionel Hampton's band during a trip to New York. For two years, he went on the road with Chuck Berry, who scored three top-10 hits during this period. Sally later became director of entertainment for the Sheraton Corporation.

Nashville-born blues singer Christine Kittrell had an extended run at the local Cadillac Club (as well as the Club Jamaica and New Frontier) in the early 1960s. She must have liked what she saw because she wound up settling here in 1962. After being severely wounded while entertaining the troops in Vietnam, she retired from music only to resume singing in the late 1980s, encouraged by local blues aficionados.

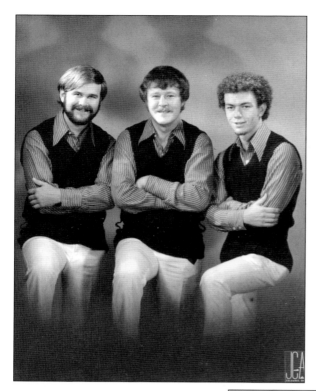

Inspired by Chuck Howard to concentrate on his songwriting, pianist Mickey Wilson wrote a few tunes for Clyde Battin (of Skip and Flip and, later, the Byrds) who was living in Minerva Park at the time. Pat Nelson, a Nashville producer, heard Wilson play and arranged for him to record a cover of the Rickie Nelson hit, "Hello, Mary Lou." (DN.)

According to Pat Zill, manager of the Boathouse, Bill Strickland was one of the few "truly all-around musicians" he ever met. Strickland and his trio, which usually included Rick Queen and Roger Wolfe, played the Boathouse for so long—off and on for 20 years—that he was dubbed "the mayor of Whitehall." (DN.)

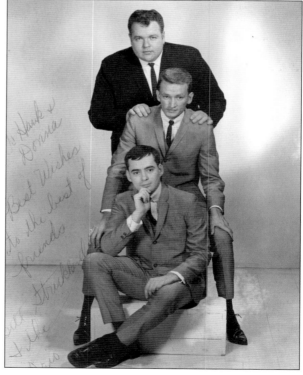

Although Billy Maxted haled from Wisconsin and made his name as house pianist at Nick's in Greenwich Village, he played so many months at the Grandview Inn that he must have considered Columbus his second home. Bob Thomas was responsible for bringing him to town originally, but it was his many fans, including Ohio State University football coach Woody Hayes, who kept him coming back for many years.

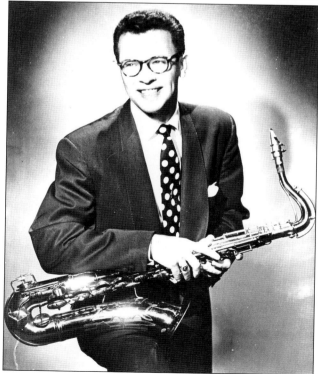

A native of Cleveland, Bob Marvin (born Marvin Fishman) began playing tenor sax professionally at the age of 17. When he came to Columbus to attend Ohio State University, he joined the bands of Chuck Selby, Ziggy Coyle, and others. Although he is best known for his television alter ego, Flippo, the Clown, Marvin led his own band for more than 30 years.

Dick Baars from Pikesville, Kentucky, started playing with Harry Epps and the Muskat Ramblers then joined Walter "Pee Wee" Hunt's band, with whom he traveled and recorded. When Hunt retired, Baars renamed the band the Slabtown Marching Society, and booked it all over the eastern United States and Canada, although Columbus remained his home base.

Tenor sax man J. C. Davis was the leader and chief soloist of James Brown's backing band, the Famous Flames, joining them in 1958. Three years later, he left "the Godfather of Soul" to assume a similar role with Etta James and Linda Jones. Over the next few years, Davis and his band backed the likes of Jackie Wilson, Sam Cooke, Otis Redding, and others, while maintaining his residence in Columbus.

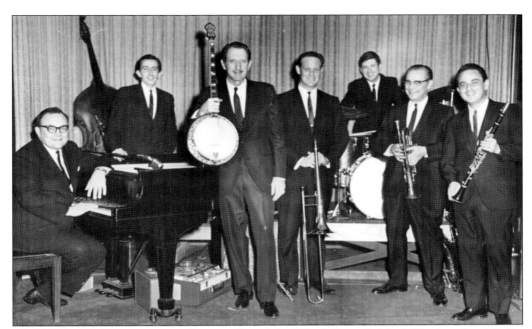

This band included some major players, such as John Ulrich (piano), Hank Harding (banjo), Jim Gary (trombone), and Howard Mauger (trumpet). Ulrich is regarded as the dean of Columbus piano players, having moved here from Evans City, Pennsylvania, in the late 1940s to attend Capital University. Although he graduated with a degree in music education, he prefers to perform.

When Young-Holt Unlimited broke away from Ramsey Lewis, the duo added William "Billy" Valentine as a vocalist. However, they soon split up. Valentine and his brother John joined a national touring company of *The Wiz* then formed their own group, the Valentine Brothers. Billy has settled into a career as a songwriter and producer and was the lead singer on the sound track of the movie, *The Five Heartbeats*.

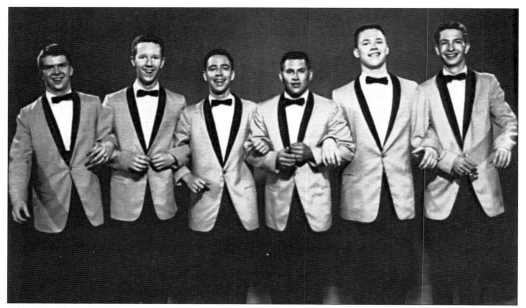

The Novelaires formed when the members were still in junior high school. Booked by agent John Moore, they found themselves working such high-profile jobs as Danny Deed's Maramor and the Roaring Twenties Room of the Deshler Hotel. Not surprisingly, a few of them went on to distinguished careers in music, including Jim Luellen, John Sheridan, Wes Orr, and Tom Swisher.

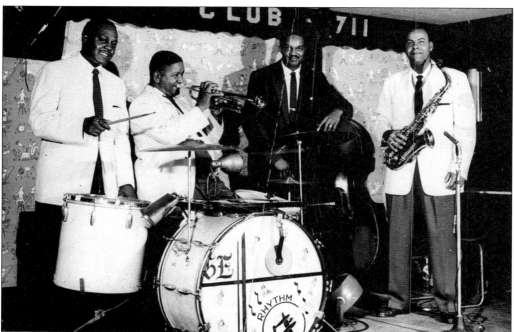

George Crowder (drums), George Emerson (trumpet), Bill Binns (bass), and Buddy Jones (sax) comprised this 1950s group that played the popular Club 7-11. Jones was the one of the city's first African American firefighters in the modern era.

Alvin Valentine (organ) and Billy Brown (drums) played the Cadillac Club in 1962. An institution on the east side, Valentine churned out a raunchy brand of funk and blues and led the popular jam sessions at the Stardust Lounge. His band also has included, at various times, the Valentine sisters and his brother William.

Supposedly, "Wild Bill" Graham could play any instrument, but he seems to have preferred the drums. He led several combos locally, particularly the Escalators, and worked at the Club 7-11, the Musical Bar, and the Melody Show Bar in Springfield. He recorded several 45s, including, "Mama Cheta," which sold quite well but is not nearly as easy to find as his cover of "Oop-Poo-Pa-Doo" on Atlantic Records.

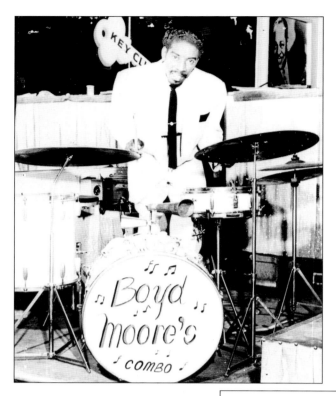

Drummer and bass player Boyd Moore led a popular orchestra during the 1950s, which gave a start to a 15-year-old tenor sax player, Ronald Kirk. Lynne Starre (also known as Rachel Mae Moore) was the featured vocalist until the band started emphasizing the rhumba. Kirk's replacement, Rudy Johnson, later was a key member of the Ray Charles Orchestra.

Charlie Pickens came to Columbus in the early 1940s to attend Ohio State University and soon began playing piano in the Lou Posey big band. After returning home to Canton for a decade, he moved back to Columbus where he led a trio at Tommy Heinrich's Restaurant and many of the other top spots throughout the city. For 13 years, he was a member of the Capital City Jazz Band.

Pianist and arranger Richard "Dick" Cone played in the Ernie Wolflie Quartet with Jim Gary and Paul Holderbaum and cofounded the Dick Cone-Sonny McBroom Orchestra. The rehearsal orchestra he put together after moving to New York became the core of the Delaware Water Gap Celebration of the Arts Festival orchestra. Vaughn Wiester's Famous Jazz Orchestra keeps Cone's inventive arrangements alive.

Columbus native Janie Tuner began her professional career as a singer and dancer at the American Legion hall on Mount Vernon Avenue. She quickly moved into some of the better clubs. In 1952, she joined Royal G. "Rusty" Bryant's band, then went on the road with the Herbie Fields Orchestra for several years. Turner was one of the first African Americans to front an all-white orchestra.

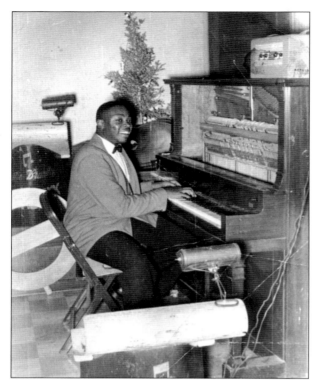

Henry "Hank" Marr started out replacing Ray "R. C." Charles as the pianist in Joe Liggins and the Honeydrippers. Returning to Columbus, he joined forces with Royal G. "Rusty" Bryant on the Carolyn Club recordings. A decade later, he had switched to organ and was signed to King Records as a replacement for Bill Doggett. Over the years, Marr developed into a highly respected arranger and master of the Hammond B-3.

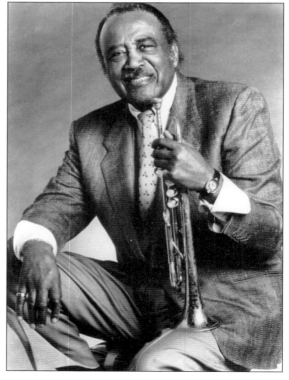

Columbus born Harry "Sweets" Edison was a prominent member of the Count Basie band, and also worked with Jimmy Rushing, Buddy Rich, and Josephine Baker. However, he is best remembered for being Frank Sinatra's favorite trumpet player. For six years, he played on every Sinatra recording and traveled with Sinatra on the road.

Jeanette Williams (Brewer) began singing in church when she was a child and turned professional at 14 when she started working with Hank Marr. Soon she was touring the United States and Europe with Marr and Bryant. In addition to being the lead singer with the band Seeds of Fulfillment, she has led her own groups and been a featured vocalist with the Columbus Jazz Orchestra.

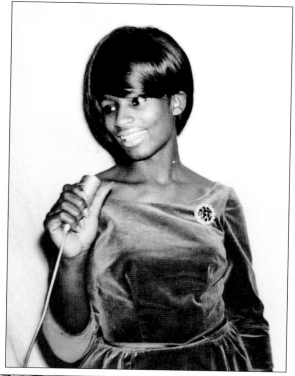

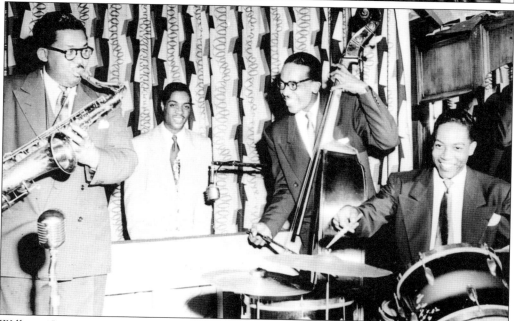

William "Jimmy" Allen was a much-feared competitor in tenor sax "cutting sessions," taking on all comers. He came to Columbus as a member of the Cal Greer Orchestra and put down roots for many years. Eventually he moved to Los Angeles where he found work playing on many movie sound tracks before being invited to conduct the orchestra at Disney World.

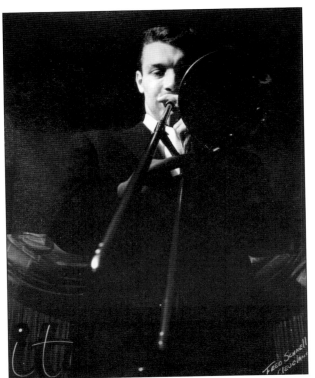

A child prodigy on the violin, Ola Hanson later established himself as a first-rate trombone and bass player. In 1955, he teamed with Charles "Chuz" Alfred to form a group that recorded the album, *Jazz Young Blood*, for Savoy Records. Later he was recruited for the Kai Winding Septet. Hanson was also a member of the Buddy Rich Quintet.

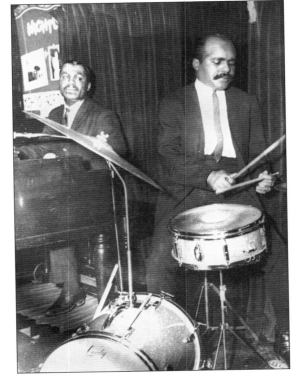

Jazz organist Johnny "Chickadee" Albert and drummer Bobby "Chickadoo" Shaw were a popular duo locally as well as in Cincinnati, Toledo, and even Philadelphia. When Charles "Merry Christmas, Baby" Brown settled into the Cadillac Club for a length stay and had to switch to organ because the club owner did not have a piano, Albert graciously set the organ stops for him since Brown did not know how.

Seven

COUNTRY ROOTS

In "Readin', Rightin', and Rt. 23," Dwight Yoakam, a Kentucky transplant, sings about the lure that Columbus and other northern cities held for job-seeking natives of Appalachia. Originally dismissed as "hillbillies" (a term that Yoakam embraced when he started his own career), this migrant community was built upon ties of kinship and tradition, particularly traditional music. As the Blues Brothers joke goes, they played "both kinds of music—country and western."

Though they may not have been the first, there is little doubt that Hank Newman and the Georgia Crackers were the most influential figures in the development of the local country music scene. Long after they had retired from the road, stars and would-be stars continued to make the pilgrimage to Hank Newman's Pizza for food, lodging, career advice, and the Saturday dusk-to-dawn jam sessions. George Jones, Loretta Lynn, Barbara Mandrell, Patsy Cline, Eddy Arnold, even Col. Tom Parker—Elvis Presley's manager—stopped by whenever they were in the area, so naturally, many local performers did so too. Big and small, their photographs hung side-by-side on the knotty pine walls of the restaurant until Newman's widow, Donna, finally shuttered it after 40 years.

In 1950, the Georgia Crackers started their G-Bar-C Ranch, a music venue, outside Columbus. It soon gave way to Frontier Ranch, which is best known for being the place where Connie Smith, a central Ohio housewife, was discovered at a Bill Anderson concert in 1964. As Dolly Parton once said, "There's really only three female singers in the world: Streisand, Ronstadt, and Connie Smith. The rest of us are just pretending."

Other well-known names in country music who have lived in the area at various times include Ricky Skaggs, Johnny Paycheck, two members of Rascal Flatts, and purportedly, Vince Gill during his Pure Prairie League days. However, Columbus has always been better known for its sidemen who, over the years, have populated the bands of everyone from Bill Monroe and Loretta Lynn to George Jones or Tammy Wynette.

Parsons Avenue on the southeast side was long the focal point of Columbus's country music scene, and until just a few years ago, the faded logo of the Early Bird Records label was still visible on a boarded-up storefront. However, the arrival of country rock in the 1970s shifted much of the activity to the Ohio State University campus area where it dispersed throughout the city.

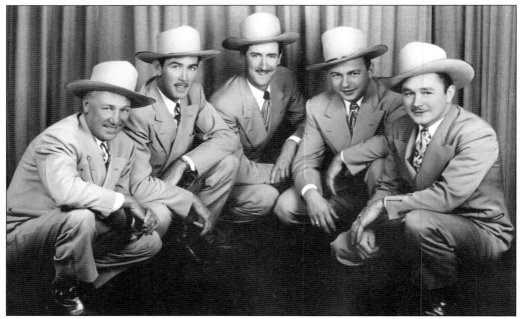

During their lengthy career in show business, Newman brothers Hank, Bob, and Slim enjoyed considerable success, including a stint in Hollywood during which they were featured in four "Durango Kid" Westerns. While Hank and Slim returned to Columbus, Bob moved to Arizona. The group also included Johnny Spies and Al Myers. (DN.)

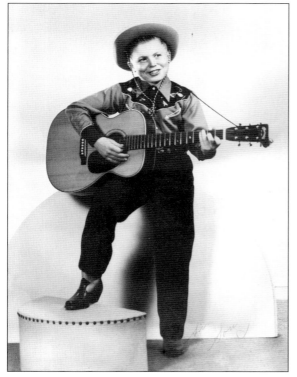

Playing a guitar that was nearly as big as he was, five-foot-tall Sonny Organ was part of the Georgia Crackers radio family. He started with the group when he was only eight but left when the "cuteness" factor wore off. The Wood Brothers, another kid act, also worked with them for a time. (DN.)

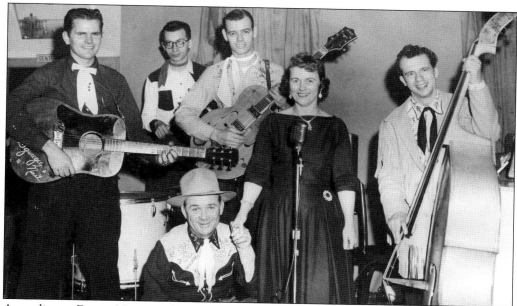

According to Donna Newman, Pappy Lee loved show business. During the 1950s and the 1960s, Lee and his Gullyhoppers played "hillbilly, rock 'n' roll, rhythm 'n' blues, and country music" at the W-B Grill, Harvey's, and the Blue Note. The group included Anne Francis, Ray Caudill, Jesse Easton, Jimmy Smith, Ray Seagraves, Rusty Lee, Billy Radar, Squeegie Nast, and Roosevelt Branham, among others. (DN.)

Sunny Lee was a singer with the Clay Eager Band in the late 1950s. An Ohio disc jockey, Eager began promoting Lee with the help of Nashville's Pat Nelson when she was just a teenager. Nelson, who was "almost a permanent boarder" at Hank Newman's house, arranged record deals for a number of local artists, including Mickey Wilson and Pat Zill. (DN.)

One of the many local groups Hank Newman discovered was the Country Playboys. He often used them as his own backing band, but when Loretta Lynn called him one night asking for help putting together a new band, Newman told her that she could not do much better than the Country Playboys. She apparently agreed because for many years, Loretta relied upon Columbus talent. (DN.)

In her autobiography, *Coal Miner's Daughter*, Lynn recalls how Chuck Flynn, her bass player, addressed the crowd when they performed a concert in Columbus. "I come from Mount Vernon, Ohio, just up the road a piece," Flynn said. "My fan club was gonna give me a parade, but one got sick, and the other had to work." (DN.)

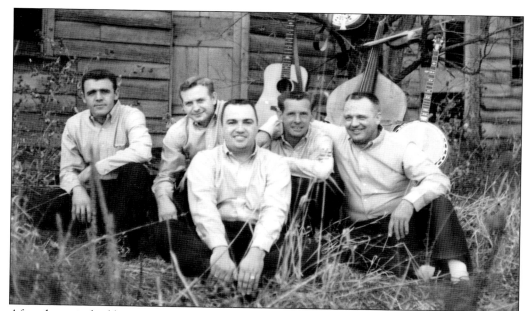

After the twist had become passé, the Gloria Night Club started holding Friday night folk-music sessions hosted by Channel 10's Chuck White. One of the featured groups was the Log Cabin Boys, which included Sid Campbell, Don Edwards, Ross Branham, and Danny Milhon, who later became the Kountry Kut-Ups. The Kountry Kut-Ups recorded the first bluegrass sound track ever used in a movie, *Football As It Is Played Today*. (DN.)

Guitarist and pianist Bill Morris often worked with his brother Don as the Morris Brothers, which usually included Dick Jeffries as well. With Phil Gary producing, Bill recorded "I'm Home," a song written by Jeff Fenholt, who played the title role in the original Broadway production of *Jesus Christ, Superstar*. Earlier, he had been a member of the Million-Airs at the Lincoln Lodge. (DN.)

When he was 23, this Columbus native formed Howard Writesel and the Write-Ones shortly after leaving Orville Busic and His Hollywood Four (so-called because they played the Hollywood Restaurant on Main Street). Along with his son John, Clyde Taylor, and Woody Browning, he played Veterans of Foreign Wars (VFW) halls and military bases, then settled into Gahanna's Riverside Club for several years. (DN.)

Robert L. (Bobby) Butler dreamed of being a country star. To help him realize his dream, he formed his own record label, Shenandoah, to release recordings by himself and others. Although he never made it big, he did help to document the Columbus country music scene during the 1960s. (DN.)

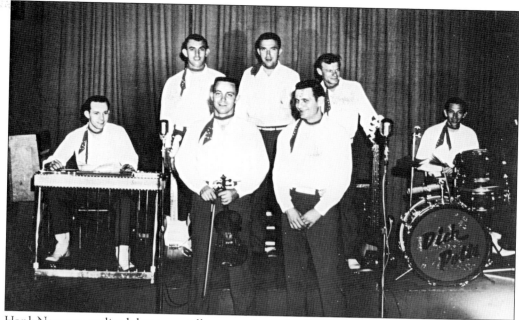

Hank Newman realized there was still some cache in the Georgia Crackers name. So in the 1960s, he put together a group of some of the best local country musicians, including Eddie Freeman, Jimmy Sykes, Ricky Lee, and Sonny Curtis, and called them the New Georgia Crackers. Pedal steel player Curtis later played with George Jones and Tammy Wynette. (DN.)

Born in a log cabin in Licking County, Kenny Sidle has never strayed far from his roots despite being crowned Ohio's (five times), Pennsylvania's (three times), and West Virginia's (two times) state fiddling champion. Early on, he decided to forsake the lure of big money in order to remain close to his family. (DN.)

Musically, the Cimarrons played everything from rock 'n' roll and twist to country western and hillbilly. Consisting of Leonard Wooley, Leonard Cline, Jack King, Lucky Castle, Bob Bozo, and Tex Cagle, they worked such venues as the Rustic Tavern and the Windsor Café. In the 1970s, they were billed as Lucky Castle and the Cimarrons. (DN.)

Originally from New York, Marty Martell began performing locally with his band, the Country Kings, when he was stationed at Lockbourne Air Force Base. Throughout the 1960s, Martell sought to establish himself as a singer, but it was as an agent for country music star Johnny Paycheck, whose real name was Donald Lytle from Greenfield, Ohio, that he made his mark. (DN.)

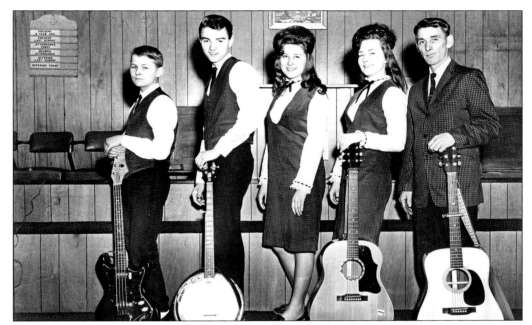

When Columbus was their stomping grounds, Glen "Pop" Marshall and his kids, Judy, Dave, Donna, Ben, and later, Danny, were simply known as the Marshall Family. But nearly 50 years later, they are remembered in bluegrass gospel circles as the Legendary Marshall Family, owing to their unusual and beautifully constructed harmonies.

Once a regular performer on the Grand Ole Opry, Jack Casey (or Casebolt) built Rome Recording Studio in Columbus with partner Dick Unteed after a 1965 automobile accident put an end to his touring. Although Unteed sold his half, Casey remained in the recording business until his death. Many well known and up-and-coming country performers have laid down tracks at Casey's studio.

Although Pat Zill, "the singing bartender," modeled himself after Frank Sinatra and Tony Bennett, promoter Pat Nelson thought he could have a future in country music. More pop than country, Zill's 1961 recording of "Pick Me Up On Your Way Down" cracked Billboard's Top 100, selling more than one million copies worldwide. (Pat Zill.)

Chuck Howard was from Flatrock, Kentucky, and came to Columbus in the late 1950s, just as Elvis Presley was hitting it big. It did not take Howard long to hype himself as the local "King of Rock and Roll" and, in truth, he was. Eventually, his songwriting talent took him to Nashville, where he turned out hits for some of the biggest names in country music as well as Ringo Starr. (DN.)

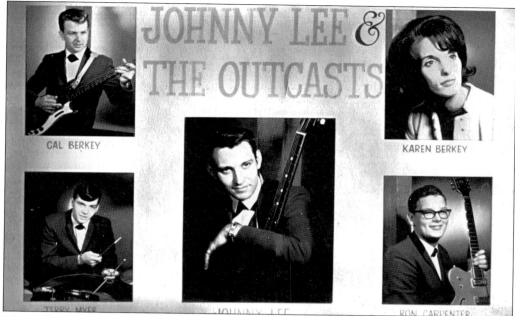

Johnny Lee and the Outcasts straddled the line between country and rock 'n' roll. The band included Karen Berkey, Terry Myer, Ron Carpenter, Calvin Berkey, and Bill Post. They played Barbie's Lounge and similar venues and also performed at the Ohio State Fair in 1967. Calvin is Lee's uncle. (DN.)

The Memories were typical of the many local country groups that played in the Parsons Avenue clubs during the 1950s and 1960s. Their first names were Leonard, Joe, and Gene; their last names have been forgotten. According to Donna Newman, they were often called on to back other performers. (DN.)

In the early 1960s, the Pacemakers included Tex Cagle, Lee Kirchner, Johnny Hines, and Billy Radar and were once billed as Tex Cagle and His Georgia Crackers. Presumably, this was with Hank Newman's approval since Cagle was a patron of Newman's Pizza. They often played the Dutch Café and Jack's. (DN.)

Ruey, John, Tom, and Ed Rhodes constituted the Rhodes Brothers. This local act quickly caught the attention of then governor James Rhodes, who got them booked at the Ohio State Fair. Within a couple of years, they had landed a recording contract with United Artist Records. While they were not exactly country, they included a lot of old-time tunes, such as "Cotton Fields," in their repertoire.

Eight

OUT OF THE GARAGE

Seventy-nine days after the assassination of Pres. John F. Kennedy, the Beatles first appeared on the Ed Sullivan Show. While parents were still groping for answers in the wake of the national tragedy, the youth of American had found theirs, and the answer was rock 'n' roll—not just listening to it but playing it. Virtually overnight, guitar sales doubled.

Like most social movements, a firm foundation had already been laid for "the garage band era." Even as the Beatles had sprung from England's skiffle craze, many American teens had already picked up acoustic guitars in response to "the great folk music scare" of the early 1960s (as Martin Mull dubbed it) and others had gone electric in emulation of various surf-rock bands. The fact is, there always had been garage bands, but now, it seemed like every fifth kid was in one.

Locally, Bud Wood put together the Nu-Trons in 1960 after he returned home from Tennessee State College. It was a typical sax-led instrumental combination of the times. Within a year, they found themselves competing with similar bands such as the Countdowns, the Bishops, the Vanguards, and the Triumphs. Gene Fullen, Jerry Rasor, and other area television and radio personalities hired the bands to work sock hops where they played when the deejays took a break from spinning records.

The Dantes, the most popular teenage band to ever come out of Columbus, was formed in 1963, months before the Beatles ushered in the so-called "British invasion." Although retaining their already dated name, they quickly adopted the English groups' fashionable mod look while continuing to cover American rhythm and blues songs.

The media got behind the music with Jerry Rasor's *Dance Party* providing a local version of an *American Bandstand*–style show. Lazarus Department Store sponsored their own "Lazaballoo," Summers and Son Music profiled a new band every week in their advertisements, and the *Columbus Dispatch* chronicled the lives of the Dantes and their girlfriends.

In Columbus, the garage band era culminated in the formation of the National Rock Opera Company production of *Jesus Christ, Superstar*. Drawing from the ranks of the Dubonnets, the Gears, the Toads, and other local bands, this "pirate" production toured 26 states and Europe before disbanding in Holland. After jamming with some of the best musicians in Europe, many members of the company returned to the United States resolved to become more serious players.

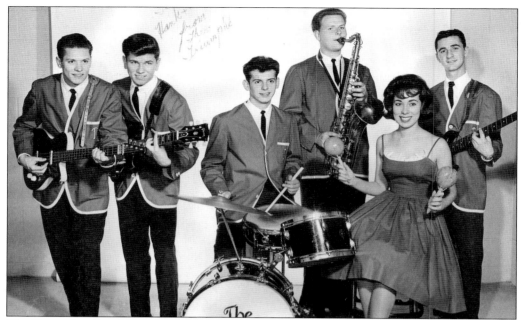

The Triumphs was one of a number of early 1960s bands that performed on WTVN-TV's *Gene's Canteen*, a local version of *American Bandstand*, hosted on Saturday afternoons by Gene Fullen. Earl Loar, Ralph Spangler, Greg Miller, Fred Morehead, Vickie Hixson, Fred Gartner, and Bruce Cady were all members of the band at one time or another. (DN.)

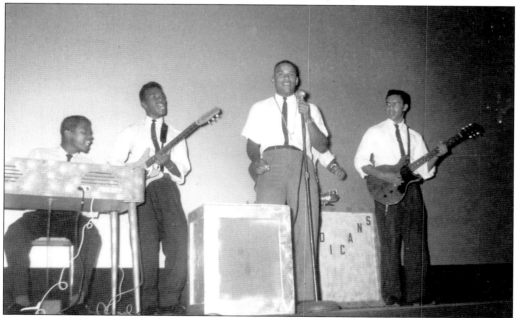

Formed in 1962, the London-based rhythm and blues group, the Vadicans consisted (at various times) of Robert "Link" Davis, Richard Peterson, Phil Lowery, Eldon Peterson, Don "Little Moe" Wilson, Larry Davis, Hank Fisher, Mickey Wallace, Gary Lee Thomas, Arnett Howard, Harold McNeil, and Bruce Smith. Their reputation quickly spread beyond their small town.

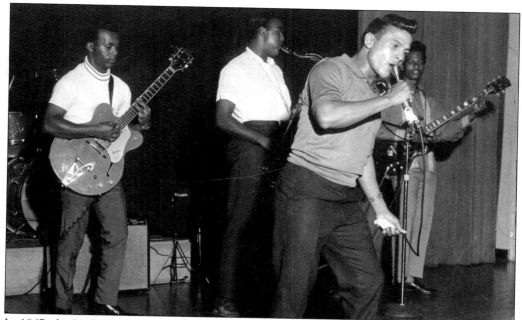

In 1967, the Vadicans included Eldon Peterson, McNeil, Wilson, and Thomas. Although they were rejected by *Dance Party*, the group had no trouble finding work in adult clubs such as the Preview Lounge, Joe's Hole, Arena Lounge, and the Mecca Club, and sometimes performed with the Columbus vocal group, the Quotations.

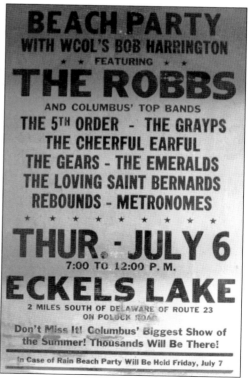

BEACH PARTY
WITH WCOL'S BOB HARRINGTON
★ ★ FEATURING ★ ★
THE ROBBS
AND COLUMBUS' TOP BANDS
THE 5TH ORDER - THE GRAYPS
THE CHEERFUL EARFUL
THE GEARS - THE EMERALDS
THE LOVING SAINT BERNARDS
REBOUNDS - METRONOMES
★ ★ ★ ★ ★ ★ ★ ★ ★ ★
THUR. - JULY 6
7:00 TO 12:00 P.M.
ECKELS LAKE
2 MILES SOUTH OF DELAWARE OF ROUTE 23
ON POLLUCK ROAD
Don't Miss It! Columbus' Biggest Show of
the Summer! Thousands Will Be There!
In Case of Rain Beach Party Will Be Held Friday, July 7

By the mid-1960s, the Columbus music scene was dominated by "the big five"—the Dantes, the Fifth Order, the Grayps, the Rebounds, and one other (there is no consensus on the fifth band). To the dismay of many veteran musicians, the best jobs were being snapped up by a bunch of kids who played with more enthusiasm than technique. (Dan Dow.)

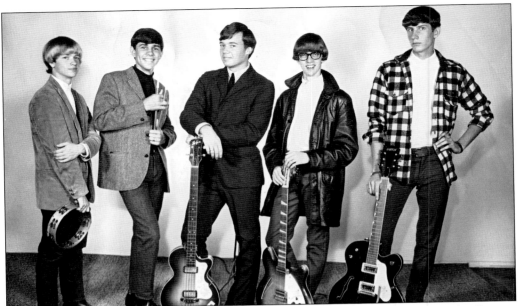

Every high school had its personal favorite, and at Thomas Worthington it was the Dantes. Anchored by the precocious guitar work of Dave Workman and lead singer Barry Hayden's Mick Jagger–Ray Davies posturing, the quintet, which included Lynn Wehr, Joey Hinton, and Carter Holliday, had the best equipment and dressed in the latest mod clothing purchased on trips to New York. (Barry Hayden.)

Within a couple of years, at least one member of the band was earning more than his father playing weekends and holidays from school. The Dantes released three 45s before they found out the hard way that opportunities were limited for a cover band, no matter how good it might be. Here they are performing at First Community Church. (Barry Hayden.)

Originally known as the Electras, the Fifth Order started at Jones Junior High with Jim Hilditch, Billy Carroll, and Mike Barand. Soon they had added Gary Stegar. Jeff Johnson, Mike Comfort, and Jeff Fenholt were among later members. Carroll recalls that they knew they had something when they performed at the Ohio State Fair before a throng of screaming teenage girls.

The Epics, from Brookhaven High School, formed in 1964 as a strictly instrumental group a la the Ventures. During their heyday, the band consisted of Mike Richards, Tim Reynard (who was replaced by Bruce Kerr), Bill Pence, Roger Pence, and Jim Miller. Managed by Scott Graves, they were installed as the house band at the popular Blue Dolphin teen club.

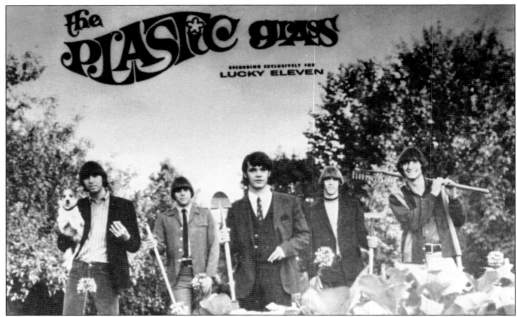

Although the Epics were signed to Michigan-based Lucky Eleven Records (the home of Terry Knight and the Pack and Question Mark and the Mysterians) and had their name changed to the Plastic Grass, none of their recordings was ever released. Consequently, they broke up in 1968. Several Columbus bands had similar experiences with record labels.

Chuck Howard took an interest in the Shilohs, producing and writing the A-side of their 45. The band was formed by Jeff Pharion and grew to include, at various times, Jim Smith, Donny Burton, Bill Butler, Bob Hughes, Bill Raffetry, Mickey Guyer, Steve Penski, Walt Erdy, Frank Weirck, Roger Riley, David Smith, and Teddy ?. Their home base was Gahanna Lanes. (Bob Hughes.)

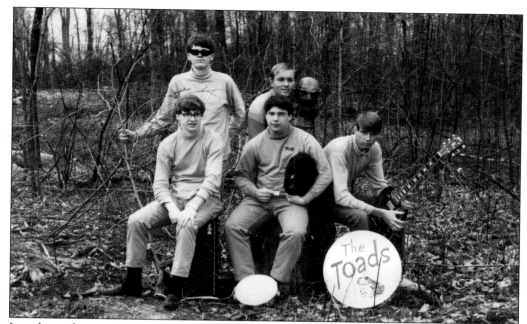

In order to draw attention to themselves in a market dominated by a handful of teen bands, Joel Brown decided the Toads would cover themselves in green paint mixed with baby oil (note their gray pallor). He failed to take into account that it would sting their eyes and stain their clothing, but it did get them work. (Chuck Wilson.)

The presence of Tina "the Girl" Elliott on keyboards helped to set the Thirteenth Dilemma apart from other Columbus garage bands. Marc Stevens and Steve Meredith, classmates at Gahanna High School, along with Steve Banish, Granville Tuttle, and Elliott managed to place fourth in the fabled 1967 Northland Battle of the Bands.

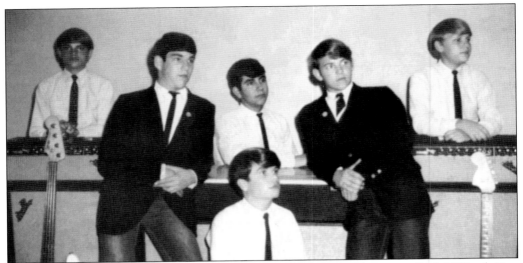

Named after a popular wine, the Dubonnets specialized in vocal harmony. Rick Hilliard, Dan Davies, Mike Mecklin, Tim Gross, Dan Westbrock, Rick Brantner, Dave Clendenon, Mike Kontras, Dave Papke, Tom Reynolds, Tim Whalen, and Mike Bauman all passed through the band. They had more formal musical training than most groups. (Mike Kontras.)

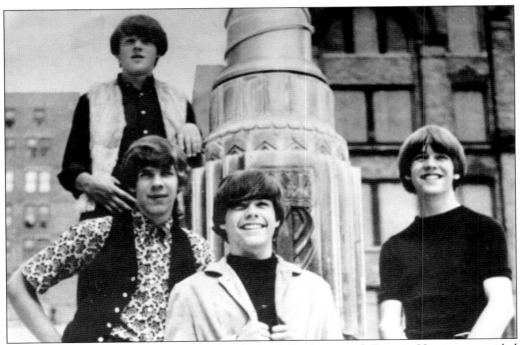

The Trolls—Joe Hanlon, Steve Westbrock, Fred Deubner, and Dennis Hassinger—prided themselves on their ability to switch off playing each other's instruments. Managed by Deubner's mother, they placed third in the 1967 Northland Battle of the Bands and competed fairly successfully with "the big five." (Dan Dow.)

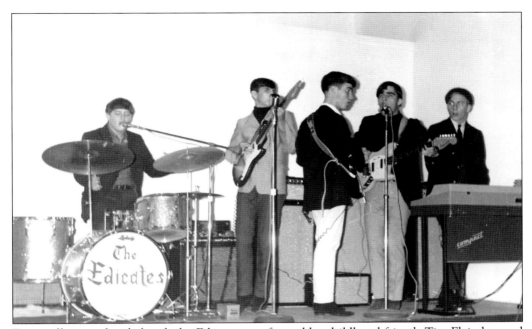

Essentially a south-side band, the Edicates was formed by childhood friends Tim Fleischer and Glenn Cataline and eventually included Mike Fitzgerald, Jim Fox, Mike Finks, Joe Dodge, Richard Shaffer, and Larry Gates. As the house band on Jerry Rasor's *Dance Party* television program for a year, their recording of "She's Gone" was a local hit. (Tim Fleischer.)

Whether Cataline accidentally misspelled "etiquette" when he was painting the band's name on his drumhead is still disputed. After all, this future member of the Godz was only 12 when he started playing professionally. "I always had more money than the other kids," Cataline recalls. In fact, his earnings paid for his college education. (Tim Fleischer.)

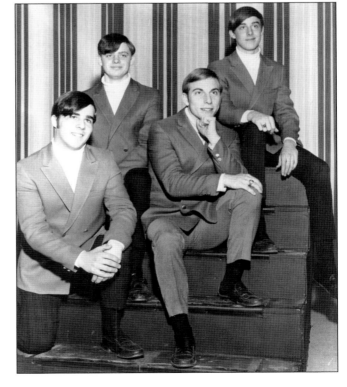

Tom Radowski, Wes Richards, and Joe Gargani put together this eastside band from the remnants of the Del Tones. They were joined by Bob Alwood, Mike Shoaf, Gary Richwine, and Joe Daniels. Although they still had a few rough edges and got in more than their share of fights, they were distinguished by the original songwriting efforts of Alwood and Daniels.

Season's Greetings

"LAPSE OF TYME"

The parents of Craig and Dennis Stickel were so supportive of their sons' band, the Lapse of Tyme, they literally turned over their entire house to them, giving up the master bedroom. Jim Dolin, Bob Ochsendorf, Gary King, Tiny Scott, Wes Shorter, and others were members of the group during its three-year run.

In 1966 and 1967, Bob Hughes was Bill Medley while Bob Blackburn was Bobby Hatfield in the In-Men, a trio that aimed for a Righteous Brothers sound. They were joined by Tom Ackley. Although they worked shows with the Dovels, Freddie Cannon, and Bobby Rydell, as well as did some recording for Cameo/Parkway, they wound up backing fan dancer Sally Rand. (Bob Hughes.)

The husband-and-wife team of Wayne and Hazel Shepherd led the Four O'Clock Balloon, Columbus's first significant exposure to West Coast "psychedelica." Along with Roger Alton, Pat Jeany, Geoff Robinson, and Jack White, they won the 1967 Northland Battle of the Bands and the opportunity to record a free single. However, disappointed by the results, they threw most of the 45s away.

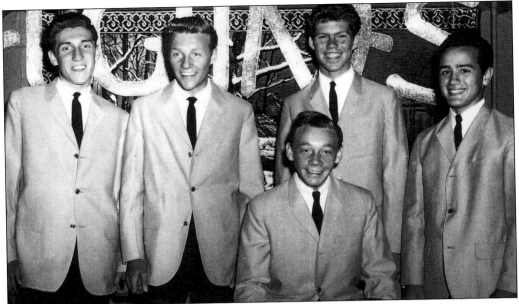

The Fugitives—Joe Lawler, Dan Donavan, Ron Auderheide, Jim Martin, and Joe Donavan—got together at Hilltonia Junior High School. They were tapped to play the RKO Palace for the opening of the Dave Clark Five movie, *Catch Me If You Can*, and the Ohio Theatre for the Beatles movie *Help!* The Donovan brothers later formed Id Nirvana with the Cars members Rick Ocasek and Ben Orr. This photograph is from 1968. (Kathleen Donavan.)

Although they had placed second behind the Four O'Clock Balloon in the 1967 Northland Battle of the bands, the Dubonnets believed their dated name and squeaky-clean image was holding them back. They became Phantom Duck after Dave Papke joined and started down a more musically adventurous path. (Mike Kontras.)

Nine

THE COLUMBUS SENIOR MUSICIANS HALL OF FAME

In 1994, Columbus historian Robert D. (Bob) Thomas asked David Meyers to assist him in creating what became the Columbus Senior Musicians Hall of Fame. It was Thomas's desire to honor many of the central Ohio musicians whose music he had enjoyed over the years. Using his weekly column in the *Columbus Dispatch* as a platform, he invited the community at large to submit nominations for the proposed hall of fame. All nominations were then reviewed by an ad hoc selection committee composed of Thomas and popular Columbus musicians Ziggy Coyle, Sonia Modes, and John Ulrich.

On June 3, 1995, the first induction ceremony took place at the Davis Discovery Center. More than 400 were in attendance to see the inaugural class of 50 recognized by their peers. Although Thomas had originally conceived of it as a one-time event, he was persuaded by Meyers to make it an on-going venture. Over the next couple of years, they incorporated the Columbus Senior Musicians Hall of Fame as a nonprofit organization whose overarching mission was to educate the public regarding the musical history of central Ohio.

Towards that end, the Columbus Senior Musicians Hall of Fame has engaged in a number of projects that have resulted in the production of a Web site, radio programs, videos, newspaper articles, and the present book. A related but separate undertaking has been the Listen For the Jazz project, sponsored by the Arts Foundation of Olde Towne, which published a book by that name covering the history of jazz on the near eastside of Columbus. The authors of *Columbus: The Musical Crossroads* were among the collaborators on that indispensable work.

Since the hall of fame's founding, more than 250 individuals have been recognized for their contributions to Columbus's musical heritage. To be considered for the hall of fame, a musician must have been born at least 60 years ago and have lived in central Ohio for a significant period of time. They represent both those who remained in Columbus throughout their careers and those who left to pursue fame on the larger stage. On the following pages is a list of all who have been inducted into the hall of fame to date, the year of their induction, and brief biographical remarks.

Inspired by the famous photograph "A Great Day in Harlem," Doral Chenoweth III staged this shot of the Columbus jazz community in 1999. He could not get them to smile until he told them to think of their favorite Yanni tune. Those pictured, in no particular order, are Keith Alexander, Vince Andrews, Patrick Ankrom, Billy Brown, Dwight Bailey, Don Basham, Edwin Bayard, Don Beck, T. Michael Branner, Christopher Braun, Bob Breithaupt, Sean Carney, Tom Carroll, Edwin Clay, Barbara "Wahra" Cleveland, Charles Cook, Ed Cottle, Michael Cox, Jim Curlis, Cary Dachtyl, Gene D'Angelo, Mary Daniels, Tim Davis, Kelly Delaveris, Dave DeWitt, Joe Diamond, Derek DiCenzo, Richie DiCenzo, Terry Douds, Leo Dworkin, "Big Al" Eichenlaub, James "Smooth" Elliott, Matt Ellis, Joe Eshelman, Ray Eubanks, Mark Flugge, Paul Francis, James W. Gaiters Jr., Jim Garee, James Gary, Jack Gorham, Steve "Paco" Grier, Larry Griffin, Fred Gump, Chris Haney, Jay Harmon, Bruce Hartung, Roger Hines, Tisha Simeral

Hines, Ronald Houpe, Arnett Howard, Christian Howes, Ben Huntoon, Kris Keith, Daniel Kelly, Robert Kraut, Peter Larson, Andy Launer, Kimberly Lawson, Dwight H. Lenox, Emile Leon, Junior Logan, Mark Lomax II, Stephan Lomax, Richard Lopez, Hank Marr, Jim Masters, Mary McClendon, Sam McCoy, Ted McDaniel, Pete Mills, Walter Mitchell, Tommy Moore, Al Myers, Roger Myers, Eddie Nix, Joe Ong, Charles Palmer, Eric "the Fish" Payton, Greg "the Governor" Pearson, Kim Pensyl, Steve Perakis, Kraig Phillips, Dave Powers, Paul Renfro, Douglas Richeson, Byron Rooker, Jim Rupp, Edwin Santiago, Aaron Scott, Robert "Bobby" Shaw, Arthur Silva, Phelton G. Simmons, Stan Smith, Bradley Sowash, Red Stamets, Don E. Tater Jr., Harold Timmons, Sidney Townsend, Louis Tsamous, Ted Turner, John Ulrich, Matt Wager, Gene Walker, Mark Warling, Pharez Whitted, Jeanette Williams, Darchelle Williams-Durr, and Phillip Winnard. (Photograph by Doral Chenoweth III; the Columbus Dispatch.)

The Columbus Senior Musicians Hall of Fame Inductees

Abbott, Martha (2001) piano/organ/composer/choir director/radio and television
Abel, Alan (1999) drums/percussion/timpani/radio, television and film/music educator
Alfred, Charles "Chuz" (1995) tenor sax/clarinet/vocals/bandleader
Allen, William "Jimmy" (2002) sax/film sound tracks/conductor/bandleader
Amspoker, Louise M. "Louise Smith" (2005) piano/vocals/organ
Anderson, Al "Rags" (1998) drums/xylophone/vibraphone/composer/music educator
Baars, Dick (1997) trumpet/cornet/bandleader/recording artist/Pee Wee Hunt Band
Baker, William P. (2002) oboe/baritone sax/tenor sax/conductor
Barksdale, Ellen Elizabeth (1999) organ/piano/choir director
Barnes, Dr. Marshall (1996) composer/music educator
Barnhart, Norman (2005) string bass/tuba/Earl March Band
Basham, Don (1998) organ/vibraphone/trumpet/trombone/bandleader
Baskerville, Arthur (Art) (1999) trombone
Battenberg, Thomas (Tom) (2001) trumpet/bandleader/music educator
Beard, Eddie (2003) piano/sax/bandleader
Beaver, Ronald (Ron) (2003) piano/trombone/television/bandleader
Bechtel, Robert H. (Bob) (2003) trombone/music educator
Beck, Donald W. (2002) guitar/bandleader/music educator
Becker, Forrest A. (1998) clarinet/sax/music educator
Betz, Paul Guilford (2004) drums/percussion/bandleader/radio
Bierly, Paul Edmund (1997) tuba/biographer/author
Boehm, R. Theodore (Ted) (1995) sousaphone/band historian
Boeshaar, Vivian (1995) organ/38-year tenure at Clarmont Restaurant
Brown, Madame Rose (1995) vocals/television and radio/starred in *Hot Mikado* on Broadway
Brown, Billy (1999) drums/congas/trumpet

Brown Sr, Ernest O. (Ernie) (2007) vocals/guitar/organ/drums/the Ink Spots
Bryant, Royal G. "Rusty" (1995) tenor sax/bandleader/national recording artist
Burczyk, Bill "Billy Romans" (2007) accordion/bandleader
Burkart, Richard H. (2001) trumpet/music educator
Butters, Robert M. (Bob) (2005) trombone/recording artist/Carl Halen's Gin Bottle 7
Buzz Saws, The (1995) barbershop quartet
Byrne, Robert (Bobby) (1999) trombone/harp/arranger/producer/bandleader
Carney, Gary (1999) trombone/piano/arranger/composer
Carpenter, William (Bill) (2001) trumpet/Jimmy Dorsey Band
Carter, Jimmy (2002) keyboards
Carter, Roses Franck (2004) string bass
Cavallaro, Carmen (2002) piano/bandleader/recording artist/radio and films
Cawley Jr., Robert Mason (1997) piano/radio and television/music director/bandleader
Cecutti, Al (1995) accordion/strolling troubadour
Cesner, Charles (Charlie) (1995) organ/television and radio
Cincione, Henry (Hank) (1995) piano/violin/bandleader/radio/Rudy Vallee Orchestra
Cincione, Alphonse (1996) baritone sax/clarinet/bandleader/music educator
Clark, John Delaney (1998) violin/trombone/conductor/bandleader
Cleveland, Frank (2007) vocals/music educator/choir director
Clonch, Charles Edward (2007) alto sax/tenor sax/clarinet/music store manager
Cole, William "Cozy" (2003) drums/percussion/bandleader/recording artist
Colston, Eddie (2003) writer/promoter
Cottle, Ed (2007) piano/Fr. Clarence Joseph Rivers Band
Cone, Richard (Dick) (2004) piano/cornet/arranger/bandleader
Cohen, Aaron "Artie Kane" (1998) vocals/organ/piano/composer/conductor
Coyle, William "Ziggy" (1995) trumpet/bandleader/music store founder
Coyle, Margie Alden (1996) vocals/radio and television
Craver. Sonny (2001) vocals/radio, television and films/producer
Craw, Esther (1995) accordion/vocals/USO entertainer
Crisp Sisters, The (2006) vocals
Crist, Wilbur E. (2006) cornet/trumpet/music educator/conductor/choir director
Cumberland, Richard (Dick) (2004) piano/vibraphone/bandleader
Cummins, Jeanne (1995) vocals/television and radio/Bernie Cummins Orchestra
Cunningham, Freddie (1998) bass/guitar/vocals/fiddle/radio
Curtis, Sonny (2006) pedal steel guitar/recording artist/George Jones
Dailey, Chuck (1998) guitar/composer/music educator
Dale, Thomas W. (Tommy) (1995) trombone/bandleader/union president
D'Angelo Jr, Eugene C. (Gene) (1995) tuba/string bass/trombone/arranger
Darnell, Larry (2001) vocals/recording artist/"Mr. Heart and Soul"/films
Daye Beckman, Marilyn (1995) vocals/radio and television
Decker, Paul (1997) drums/bandleader/Sammy Watkins Orchestra
DiCenzo, Richard (1996) clarinet/sax/radio/USO performer
Dini, Roger (2005) accordion/bandleader
Dixon, Lawrence "Beau" (2002) banjo/guitar/cello/recording artist
Downing, Vera Watson (1997) viola/violin/music educator/conductor
Droste, Dr. Paul E. (1995) euphonium/educator/band director
Dworkin, Abraham (Abe) (1995) trumpet/Art Jarrett Band
Dworkin, Leo (1998) trumpet/Pee Wee Erwin Band/worked "ghost band" circuit
Edison, Harry "Sweets" (1999) trumpet/recording artist/radio and television
Ellis, Tony (2004) banjo/recording artist/Bill Monroe's Bluegrass Boys
Elzy, Ruby (2007) vocals/radio and films/starred in *Porgy and Bess* on Broadway

Epp, Harry (2003) piano/flute/piccolo/clarinet/banjo/bandleader

Eubanks, Ray (2003) trumpet/vocals/music educator/founded Jazz Arts Group

Evans, Jack (1995) band director/educator

Evans, Mike (2004) vocals/banjo/music educator/bandleader

Evans, Vince (2005) bass/vocals

Everhart, Robert A. "Doc" (1995) sax/bandleader

Everhart, Robert (Bob) (2006) trumpet/bandleader

Falcons, The (or the Lyrics) (2006) vocal group/recording artists

Fidler, Richard E. (Dick) (1995) piano/bandleader/radio/composer

Fishman, Marvin "Bob Marvin" (2004) tenor sax/drums/vocals/trombone

Fluke, Jim (2006) trombone/bandleader

Foucht "Fote," Nelson (2001) trombone/music educator/bandleader

Four Pharaohs, The (or the Columbus Pharaohs) (2005) vocal group

France, Pete (2004) trumpet/music educator/conductor

Franck, James (Jimmy) (1995) trombone/bandleader/Nelson Riddle Band

Fullen, Ruth (2004) string bass/vocals

Garrett, Roger (1995) theater organ/piano/radio and television/station manager

Gary, James (1999) trombone/bandleader

Genteline, Steve (2006) baritone sax/television/music educator/band director

Georgia Crackers, The (1995) vocal and instrumental group/radio and movies

George, Thomas O. (Tom) (2007) trombone/drums

Giammarco, Salvatore "Sam" (1995) trumpet/music educator

Ginnetti, Joseph N. "Joey Nichols" (2005) piano/entertainer

Good, Cleve (2004) alto sax/union president

Gordon, Archie "Stomp" (2002) piano/vocals/composer/recording artist/bandleader

Gorham, Jack (2003) drums/percussion/bandleader

Gray Chatfield, Jaylene (1995) vocals/television

Green, Burdette (1997) sax/flute/music educator

Groves, Dale (2007) trombone/bandleader/cofounded Fabulous Forties Orchestra

Gump, Fred (1996) drums/percussion/bandleader

Gundersheimer, Muriel (1999) harp

Haddad, Dr. George R. (1995) concert piano/music educator/adjudicator

Haines, Don (1998) organ/piano/bandleader

Hanson, Ola (1997) violin/trombone/bass/trumpet/vocals/Kai Winding Septet

Hardesty, George (1995) violin/concert master/conductor

Harmonaires, The (1995) vocals group/radio, television, and movies/recording artists

Harriman, Glenn (1996) trombone/music educator

Heine, Richard (Dick) (1995) clarinet/radio and television/arranger

Hennen, Donald "Don Crawford" (1995) baritone sax/bandleader

Hightshoe, Robert B. (1997) trumpet/music educator

Hill, Robert E. (Bob) (1999) clarinet/sax/music agent

Hood, Earl (1995) violin/bass sax/bandleader/longtime Valley Dale house band

Hopkins, Samuel W. (1996) alto sax/bandleader/Lucky Millinder Orchestra

Horsefield-Carney, Michelle (1995) vocals/premiere vocal coach

Hughes, Bob (2007) guitar/vocals/bandleader/producer/Joey Dee and the Starlighters

Hummel, Fritz (1995) trombone/Casa Loma Orchestra/Paul Whiteman Orchestra

Huning, Sylvia (Syl) (2002) violin/strolling troubadour

Hunt, Walter "Pee Wee" (1999) trombone/vocals/bandleader/recording artist

Jelley, Robert "Bob Jolly" (2005) trombone/bandleader/Tommy Reynolds Band

Johnson, Dorothy Jones (2007) vocals/recording artist/cofounded the Cookies

Jones, Wendell (2001) virbraharp/percussion/television/music educator

Kenny, Carl "Battle Axe" (2002) drums/percussion/James Reese Europe Orchestra

Kimmel, Glenn (2001) drums/percussion/Pee Wee Hunt Band/Tex Beneke Band
Kinnan, Frank (2002) clarinet/tenor sax/alto sax/music educator
Kirk, Ronald T. "Rahsaan Roland" (1996) sax/flute/bandleader/composer
Kittrell, Christine (1998) vocals/recording artist/USO performer
Kline, Morrie (1998) piano/organ/television/music educator
Knick, Walter (1995) piano/bandleader/radio and television/longtime tenure at Jai Lai
Knoll, Lee (1995) guitar/radio/music educator
Lamplighters, The (2004) vocal group
Langston, Jerry K. (1998) guitar/radio and television
LaRue, Frank (1996) violin/vocals/trombone/bass/arranger/Stan Kenton Orchestra
Launer, Andy (2002) piano/trombone/bandleader/composer/radio and television
Lewis, Ted (or Theodore Friedman) (2001) clarinet/bandleader/radio, television and films
Linwood, Lucille Beckwith (1997) vocals/television/understudy for Kate Smith
Logan, Kay Hardesty (2004) flute/music educator/author
Lord, Joe (1999) clarinet/sax/flute/trombone/recording artist/television
Lowery, Percy (1995) tenor sax/bandleader
Luellen, Jim (2006) piano/clarinet/trumpet/sax/trombone/bandleader
Marie Leighty, Donna (2001) piano/organ/vocals
Marr, Henry (Hank) (1995) piano/organ/bandleader/recording artist/arranger
Martin, Ida Eugenia (2002) alto sax/organ/piano/bandleader/choir director
Masdea, Bruno (1996) trumpet/bandleader/founder Fabulous Forties Dance Band
Masdea, Joseph (1997) trumpet/bandleader
Mauger, Howard "Howdie" (1995) trumpet/bandleader/arranger
McAndrews, John A. (Jack) (1995) piano/violin/organ/bandleader
McBroom, Dr. Clarence "Sonny" (2003) sax/bandleader
McGinnis, Dr. Donald (1996) flute/clarinet/music educator/conductor/author
McKaig, Gary (2006) trombone/recording artist/USO entertainer/bandleader
Modes, Sonia (1996) piano/bandleader/"The First Lady of Piano in Columbus"
Molleur, Paul (2001) piano/bandleader
Moore, James L. (Jim) (1997) drums/percussion/music educator/author
Myers, Al (2001) guitar/banjo/recording artist/bandleader
Nafzger, Rose Thall (1998) vocals/piano/radio pioneer/bandleader
Napper, Sr., Leonard Nelson (2006) vocals/choir director/artistic director
Neal, Paul "Snook" (1996) trumpet/piano/organ/celeste/vibraphone/arranger
Near, Randall W. (1996) violin/music educator/music director/bandleader
Newkirk, William H. (2004) piano/clarinet/bass/tenor sax/conductor/composer
Nix, Eddie (1998) drums/percussion/bandleader
Norris, Riley (2004) trumpet/bandleader/films/music educator/arranger/bandleader
O'Brien, Janet (2005) piano/choir director
Ogden, Becky (2006) sax/music educator/author/promoter
Oliva, Andy (2003) clarinet/sax/flute/radio
Orr, Wesley (Wes) (2003) trumpet/music educator
Ostrander, Elaine (2001) sax/clarinet/conductor/music store owner
Ostrander, Tom H. (2007) baritone horn/bass trombone/music educator
Padilla, Marcel "Marsh" (1999) sax/flute/clarinet/guitar/bass/marimba/bandleader
Patterson, Don (2001) piano/organ/recording artist/bandleader
Peppe, Lou (1998) owner and operator of Valley Dale
Peppe, James (Jimmie) (2001) mandolin/banjo/guitar/bandleader/manager
Perrini, Nicholas J. (Nick) (2003) French horn/piano/violin/music educator
Pickens, Charlie (1997) piano/bandleader/radio
Polster, Ian (2007) trombone/vocals/music educator/arranger/composer/conductor
Pooch, Willie (1999) vocals/bass/bandleader

Powell, Raymond "Papa Honk" (2001) sax
Prahin, Robert "Bob Allen" (2002) piano/arranger/bandleader/recording artist
Racle, Ray (1998) drums/percussion
Randolph, Harland T. "Raleigh" (1995) vocals/bass/bandleader
Renfro, Paul (1999) sax/recording artist
Ricketts, Robert Webb (1998) sax/Sammy Kaye Band
Riley, Lowell (1995) piano/organ/choral director/vocals/cofounder of Vaud-Villities
Rivenberg, Leonard (2002) French horn/music educator
Rivenberg, Margaret (2002) English horn/oboe/music educator
Rogers, Jimmy "Stix" (1998) drums/percussion/marathon drumming champ
Rubinoff, David (1995) violin/conductor/composer/radio star
Russell, Jim (2007) clarinet/tenor sax/flute/organ/vocals/music educator
Ryerson, Art (2004) guitar/banjo/mandolin/radio/recording artist
Saenger Sr., J. Frederick "Fritz" (2002) piano/timpani/choir director/
Sally, Carl (2002) sax/bandleader
Schaeffer, Franklin (2002) flute/piccolo/music education
Schmalz, H. "Joe" (1997) accordion/bass/television/bandleader/Bernie Cummins Band
Seelbach, Don (1999) clarinet/sax/oboe/music educator
Selby, Charles (Chuck) (1995) sax/bandleader/radio/managed Valley Dale
Shaw, Bobby (1997) vocals/piano/organ/bandleader
Sheridan, John (2005) piano/arranger/radio/Jim Cullum Jazz Band
Sillman, Avrom Joel "Al" (1997) tenor sax/clarinet/Woody Herman Band
Simmons, Phelton (1997) bass/bandleader/USO performer
Sours, Chet (2006) piano/organ/Jack Yaeger Band
St. Claire, Bette (or Betty Waddell) (1997) vocals/recording artist
Stamets, John "Red" (1997) trumpet/vocals/bandleader/television/Billy Butterfield Band
Staten, James (Jim) (2004) sax/clarinet/flute/music educator
Steinhaurer, William (1995) violin/radio/music director/music educator
Stewart, Samuel (Sammy) (1995) piano/arranger/recording pioneer
Stewart Jr, Bill (1999) alto sax/recording artist/Jay McShann Combo
Stewart Sr., Bill (1999) alto sax/clarinet/USO performer/McKinney's Cotton Pickers
Suddendorf, Richard J. (2005) cornet/trumpet/conductor/music educator
Supremes, The (or the Columbus Supremes) (2004) vocal group/recording artists
Susi, Joseph F. (Joe) (1995) trumpet/Bobby Sherwood Band
Susi, Les (1996) trumpet/music educator/conductor/band director
Swisher, Tom (2004) drums/percussion/Dick Baars Dixieland Band
Tate, Dr. Donald (Don) (2003) trumpet/valve trombone/tenor sax/bandleader
Tatgenhorst, John (1999) drums/percussion/piano/arranger/composer
Thomas, Robert D. (Bob) (2003) cofounder of the Columbus Senior Musicians Hall of Fame
Tolbert, Dr. Mary (2002) author/lecturer/music educator
Tooill, Mac (1996) piano/bandleader/USO performer
Trimble, Richard (Dick) (2003) clarinet/sax/bandleader/music store owner
Turner, Theodore H. (1996) cornet/trumpet/music educator/arranger
Turner, Jane (Janie) (2002) vocals/Herbie Fields Orchestra
Tyack, Norman (2001) piano
Ulrich, John (1996) piano/trumpet/virbraphone/music educator/television/author
Utz, Carolyn G. (1996) piano/string bass/music educator
Vaughn, Betty (2001) piano/vocals/bandleader
Volpe, Don (1999) trumpet/Charlie Barnett Orchestra
Waldo, Terry (2006) piano/vocals/composer/arranger/author/bandleader
Walker, Gene (1998) tenor sax/alto sax/recording artist/bandleader/music educator
Wallace Brothers, The (2003) vocal and instrumental group

Waslohn, Al (1995) piano/arranger/composer/bandleader/television/recording artist
Weisberg, Joseph (Joe) (1995) piano/television/musical director for *Cinderella*
Whallon, Evan (1997) piano/conductor/musical director Spoletto Festival
Wheeler, Dave (1997) clarinet/sax/keyboards/arranger/music educator
White, Chuck (2004) guitar/vocals/television/composer
Widner, Jack (2003) piano/bandleader/television
Wiester, Vaughn (2007) trombone/arranger/bandleader/music educator
Wild, Earl (2001) concert piano/radio and television/recording artist/Grammy award winner
Wiley, Cornell (1998) vocals/bass/recording artist/television/music educator
Wilson, Nancy (1995) vocals/recording artist/radio and television/Grammy award winner
Wilson, Glen E. (2002) string bass/radio/bandleader
Wilson, Patricia (Pat) (2003) vocals/television and films/appeared in *Fiorello* on Broadway
Wolfle, Jr, Dr. Ernest E. (Ernie) (2003) trumpet/bass/bandleader/music educator
Wolstein, Leonard E. "Lennie Wynn" (2002) vocals/trumpet/piano/bandleader
Woode, Bruce (2003) bass/bandleader
Woods, Dr. Jon R. (2003) bandleader/music educator/band director
Young, Anne (1996) vocals/bandleader/television
Ziegler, Franz (1995) violin/music educator/bandleader
Zumbrunn, Karen Fanta (2005) piano/bandleader/music educator

ACROSS AMERICA, PEOPLE ARE DISCOVERING SOMETHING WONDERFUL. *THEIR HERITAGE.*

Arcadia Publishing is the leading local history publisher in the United States. With more than 3,000 titles in print and hundreds of new titles released every year, Arcadia has extensive specialized experience chronicling the history of communities and celebrating America's hidden stories, bringing to life the people, places, and events from the past. To discover the history of other communities across the nation, please visit:

www.arcadiapublishing.com

Customized search tools allow you to find regional history books about the town where you grew up, the cities where your friends and family live, the town where your parents met, or even that retirement spot you've been dreaming about.